thank you to:
my best friend/husband, Aaron

and my sweet parents, Dennis + Donna

Thank you for always supporting and
believing in my crazy lettering dreams.

ISBN: 9781944515546

CONTENTS

It's here! I am so excited that *Hand Lettering 201* is finally a book, and that you are holding it in your hands. Do you love it so far? Did you skip *Hand Lettering 101* and jump straight to 201? I won't judge you! This book will be a bit different than 101, however. There will still be plenty of space to practice and work inside the book, but we will also dive deeper with different letters, tools, design discussions, final projects, and so much more. I was so happy that y'all loved *Hand Lettering 101* so much, and I cannot wait to teach you more of what I love.

Never heard of Sarah from Chalkfulloflove? Well, let me introduce myself! I am a (late) twenty-something who has been lucky to make a career of drawing letters. Is there anything better? Probably not! I run a home goods + gift shop from my home in Austin, Texas. Everything I create is designed by me, and usually includes lots of hand lettering.

My lettering has changed so much since I wrote *Hand Lettering 101*, and I am sure it will continue to evolve— and so will yours! That is truly the beauty of lettering. There are so many different styles, methods, and tools that continue to help us grow and evolve. I mean, have you seen the iPad Pro®? Since its introduction into my life, my workflow has completely shifted. Don't worry, I will explain more on that later!

As you continue to learn and grow in your new hobby, I want to reiterate that it won't always come easily or naturally to everyone. That's okay! Use this book as a guide to help you learn, and develop your own style. Just because your letterforms don't look exactly like mine doesn't mean they aren't beautiful! You do you.

cheers,
Sarah

PART ONE

Okay, let's dive right in, girl. I know you are here to letter! Feel free to utilize the space in this book to practice on your own. When that runs out, grab a piece of tracing paper and do it again. Like we say in the lettering world, practice makes perfect. (You will also find pen recommendations at the top of each alphabet.)

There will be multiple alphabets that stem from the original alphabet you learned in *Hand Lettering 101*. It's amazing how much you can do to just one alphabet to make it change. You'll notice some exaggerated loops, extreme angles, and different faces and tails. I am also introducing you to some new pens + tools. These tools can give the same alphabet so many different feels.

TIPS + TRICKS

✗ If you feel like you aren't quite grasping a certain alphabet, move on to the next! These are just practice prompts; they won't all be your favorite.

✗ If your hand is cramping, take a break! This is supposed to be relaxing, so don't overwork yourself.

✗ If you run out of practice space or don't want to write in your book, grab some tracing paper.

✗ Take your time. The slower you go with your letter form, the easier it is for you to feel the movements of each stroke.

✗ Practice, Practice, Practice. As we've discussed before, this doesn't come naturally to everyone. My lettering skill and style has developed over a lot of time and with a lot of practice!

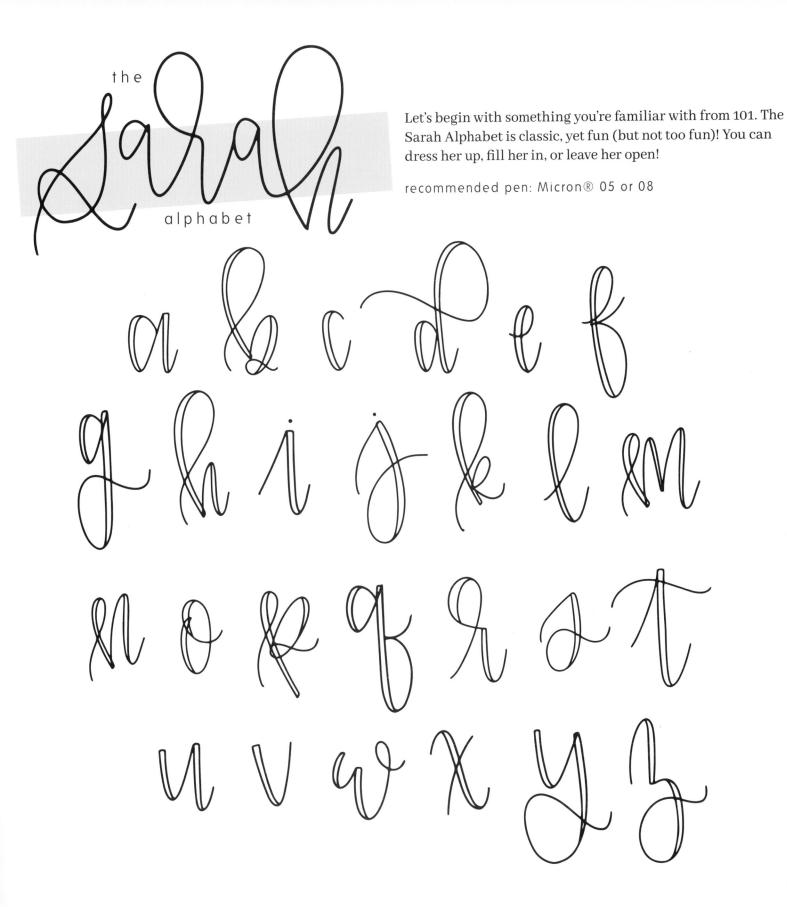

Let's begin with something you're familiar with from 101. The Sarah Alphabet is classic, yet fun (but not too fun)! You can dress her up, fill her in, or leave her open!

recommended pen: Micron® 05 or 08

 Trace the letter shapes by following the arrows, then use the space to the right to practice on your own!

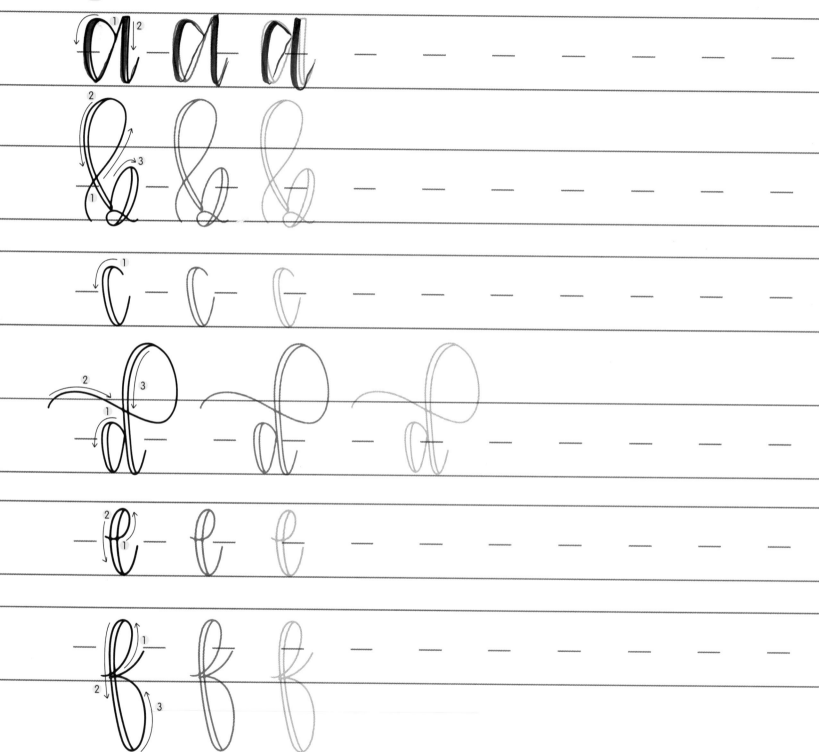

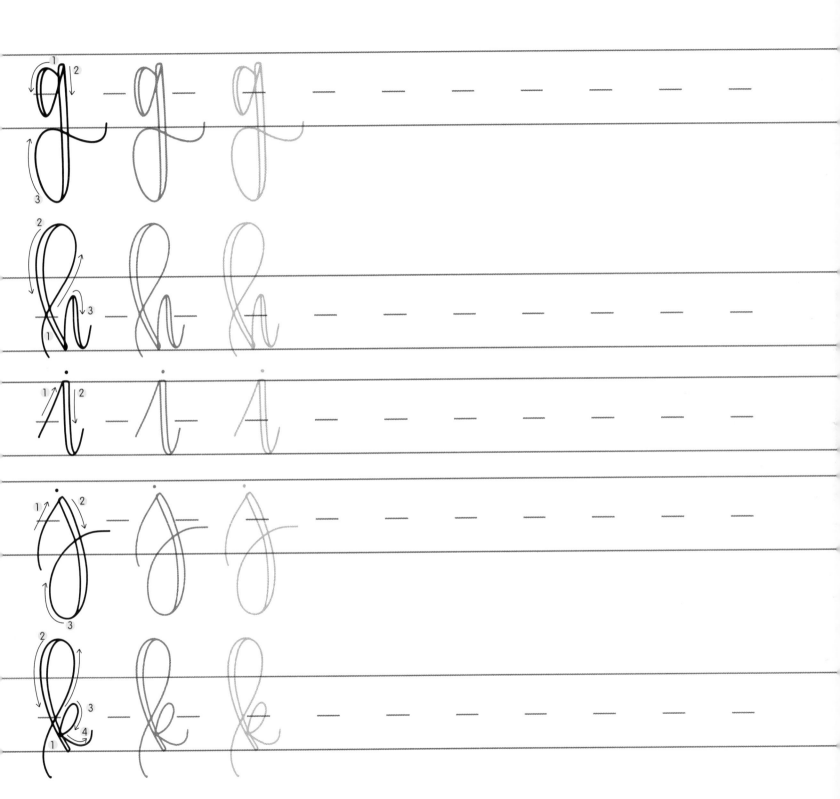

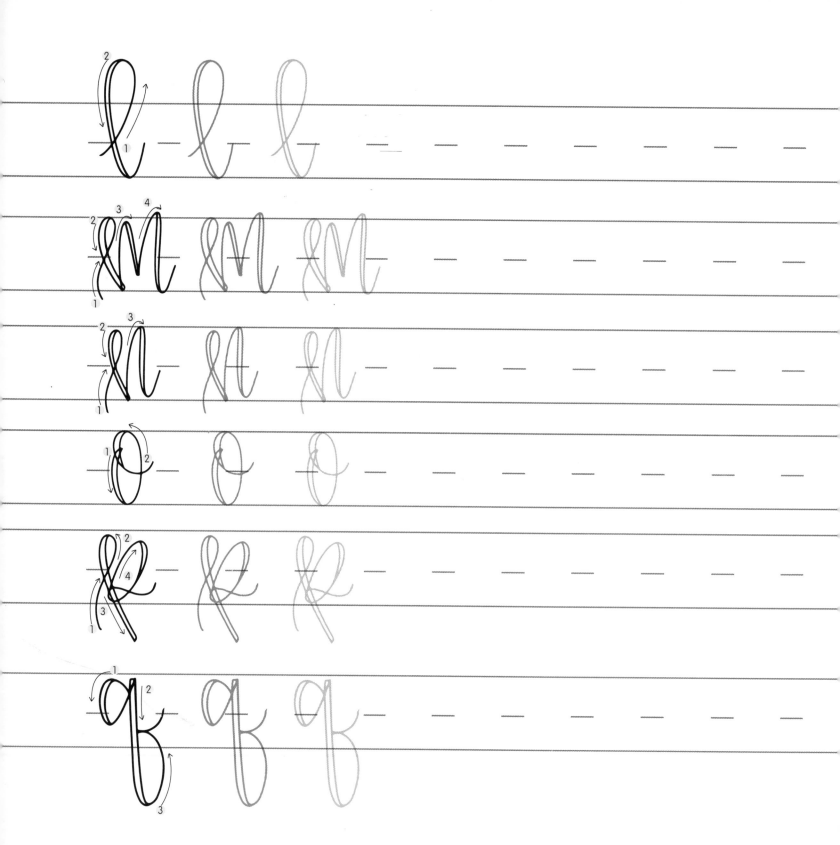

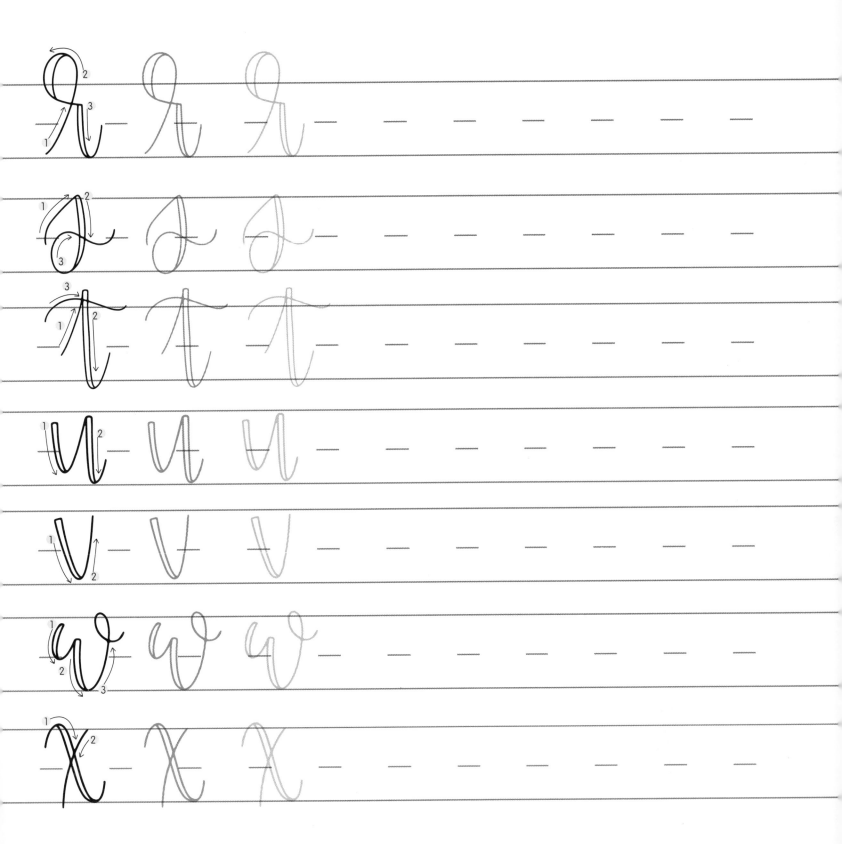

11

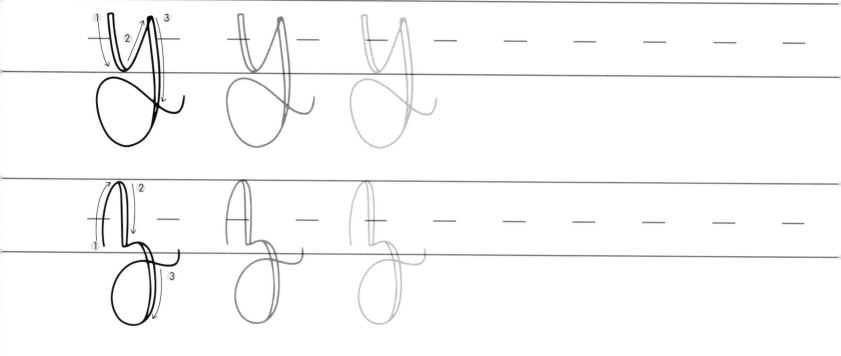

BREAKING IT DOWN

If you are familiar with *Hand Lettering 101*, you might recognize the subtle changes in the Sarah Alphabet. It's been a little over a year and a half since I created the first book. Just when I thought I was finished evolving my alphabet, it changed a bit. That is the beauty of this style of lettering: it can be manipulated and changed ever so slightly to create a totally different feel. As we discussed in 101, it is all about memorizing the muscle movement of each letter. From there, you can change things like the size of the face, the tail of your letter, the angle, certain flourishes, whether or not you widen it, or even use different tools.

This is what we will be doing with the next sets of alphabets. I created several iterations by making these types of changes. Get your hand ready!

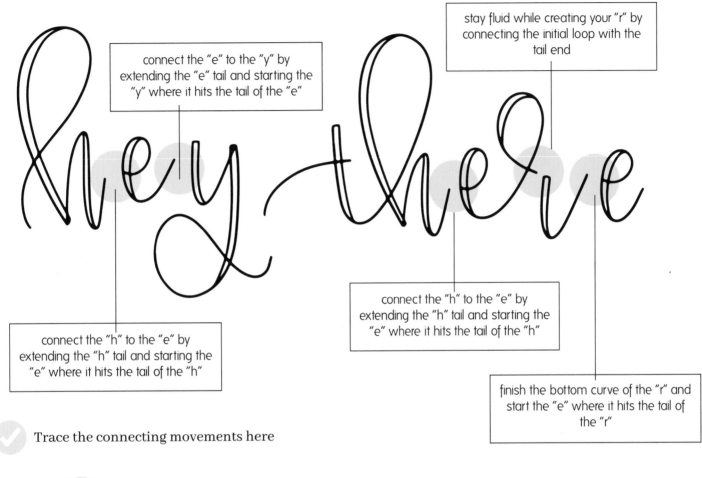

connect the "e" to the "y" by extending the "e" tail and starting the "y" where it hits the tail of the "e"

stay fluid while creating your "r" by connecting the initial loop with the tail end

connect the "h" to the "e" by extending the "h" tail and starting the "e" where it hits the tail of the "h"

connect the "h" to the "e" by extending the "h" tail and starting the "e" where it hits the tail of the "h"

finish the bottom curve of the "r" and start the "e" where it hits the tail of the "r"

Trace the connecting movements here

13

 Use the space below to practice connecting with the Sarah Alphabet!

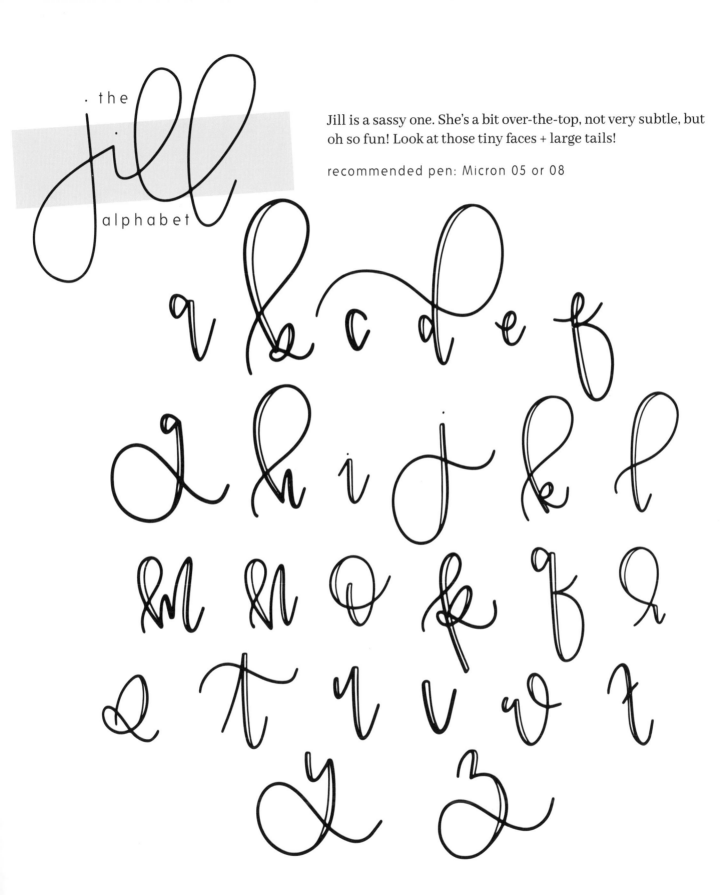

the jill alphabet

Jill is a sassy one. She's a bit over-the-top, not very subtle, but oh so fun! Look at those tiny faces + large tails!

recommended pen: Micron 05 or 08

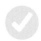 Trace the letter shapes by following the arrows, then use the space to the right to practice on your own!

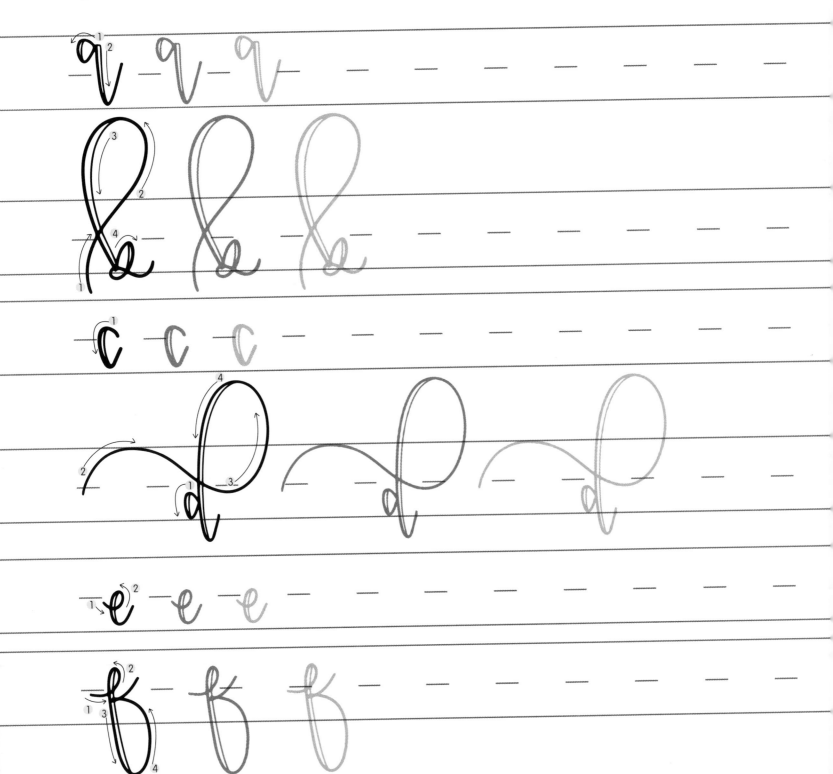

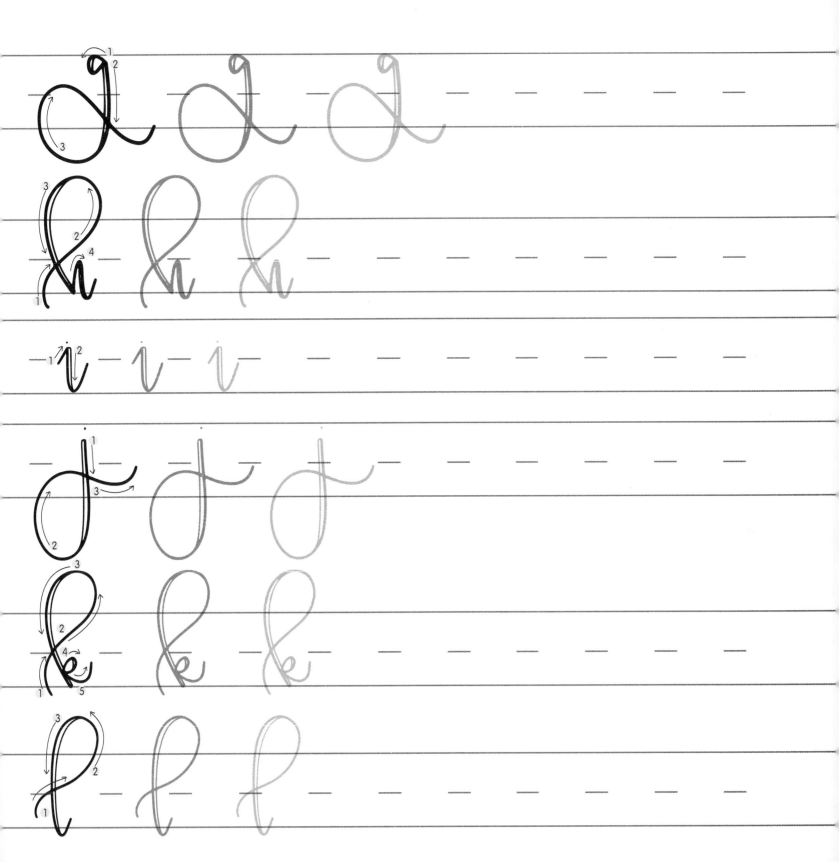

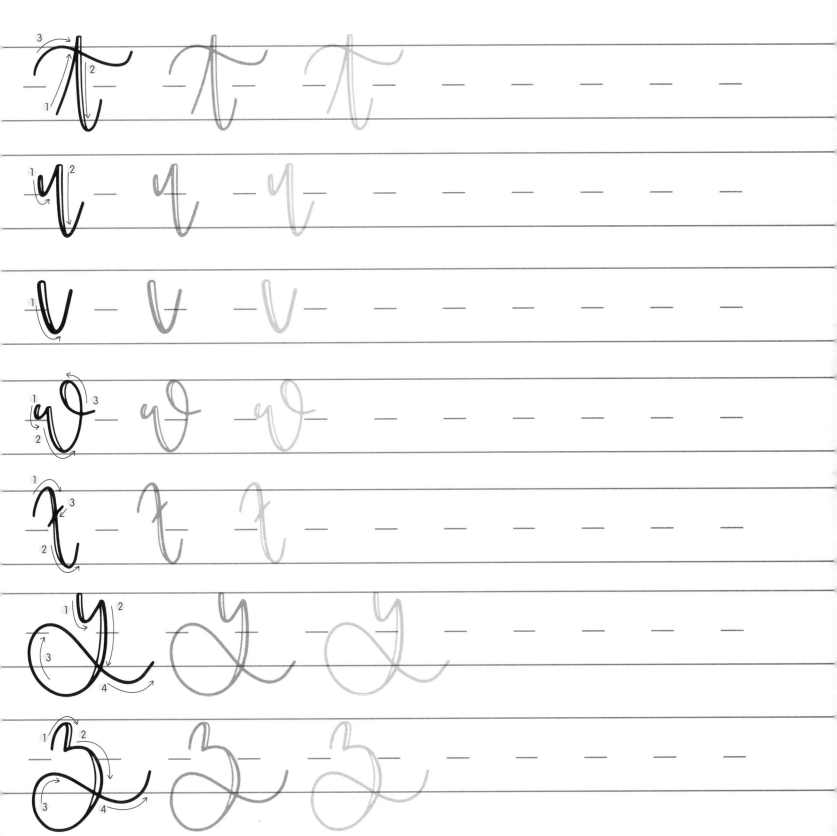

connect the "o" to the "u" by extending the "o" tail and starting the "u" where it hits the tail of the "o"

connect the first "o" to the second "o" by extending the first "o" tail and starting the second "o where it hits the tail of the first "o"

stay fluid between the "o" and the "k" loop. Finish the "k" b picking up your pen to start the "k" face!

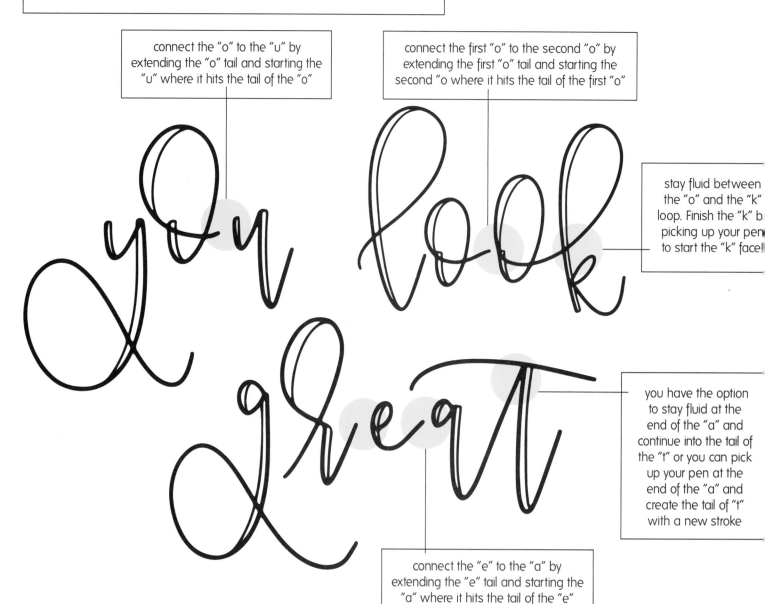

you have the option to stay fluid at the end of the "a" and continue into the tail of the "t" or you can pick up your pen at the end of the "a" and create the tail of "t" with a new stroke

connect the "e" to the "a" by extending the "e" tail and starting the "a" where it hits the tail of the "e"

 Trace the connecting movements here:

 Use the space below to practice connecting with the Jill Alphabet!

emma

Like Jill, Emma is a sassy one and takes her look over-the-top by widening her letter forms. Try to keep a consistent 45-degree angle when drawing her tails.

recommended pen: Micron 05 or 08

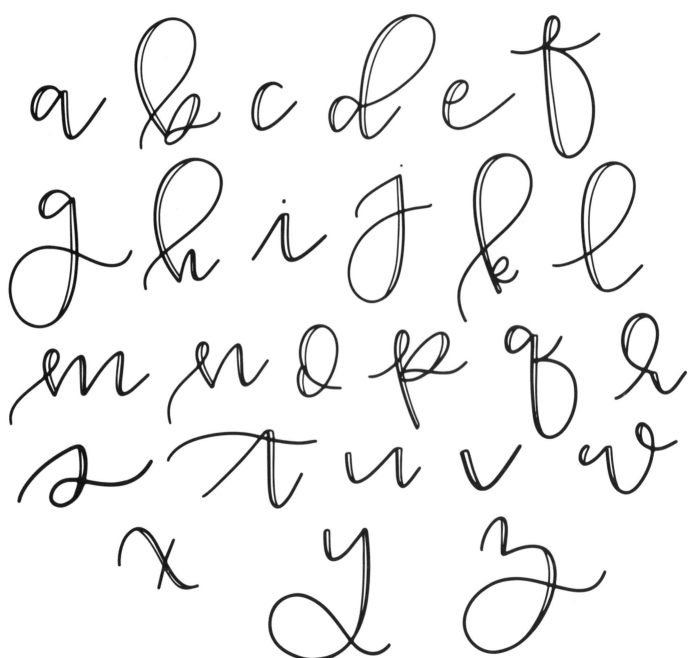

 Trace the letter shapes by following the arrows, then use the space to the right to practice on your own!

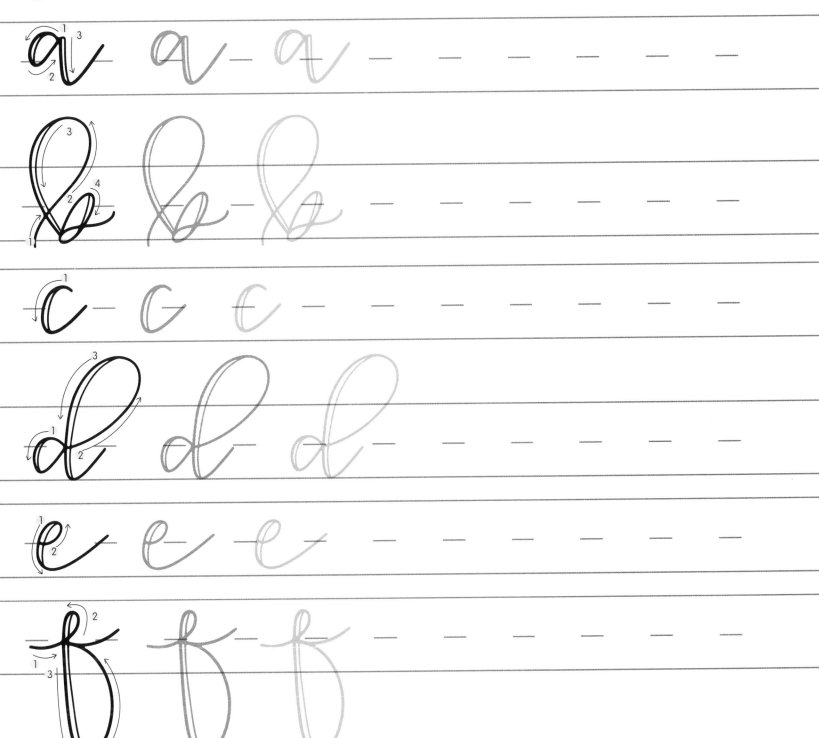

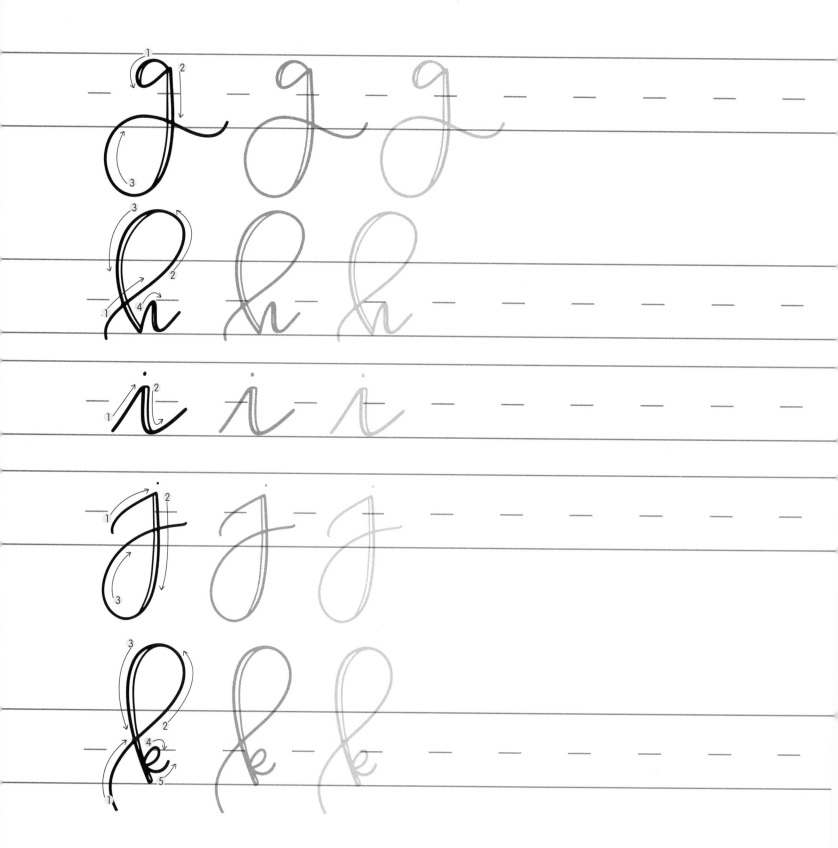

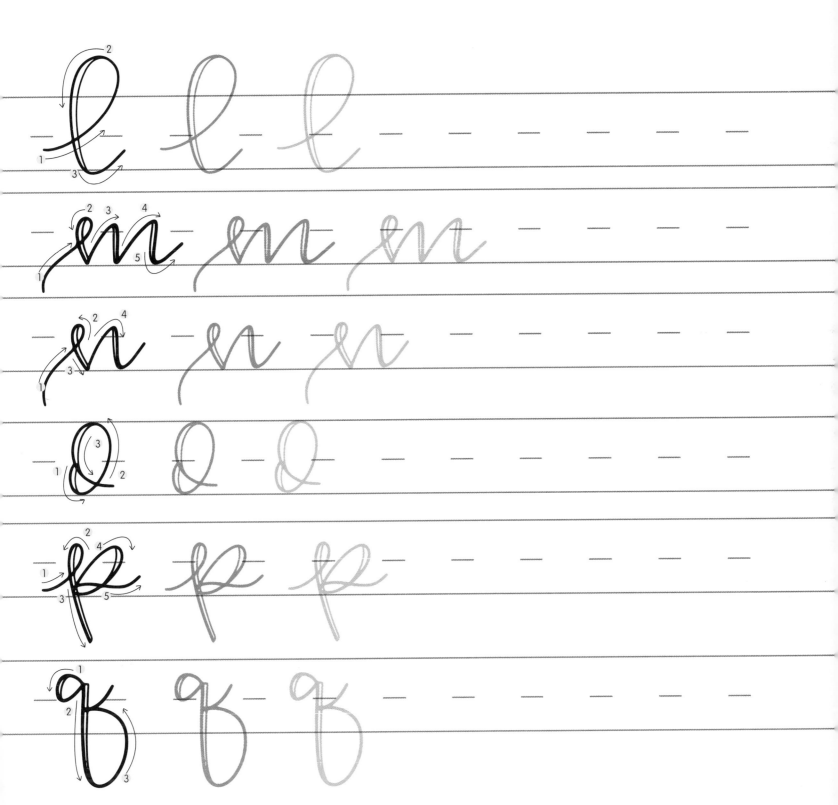

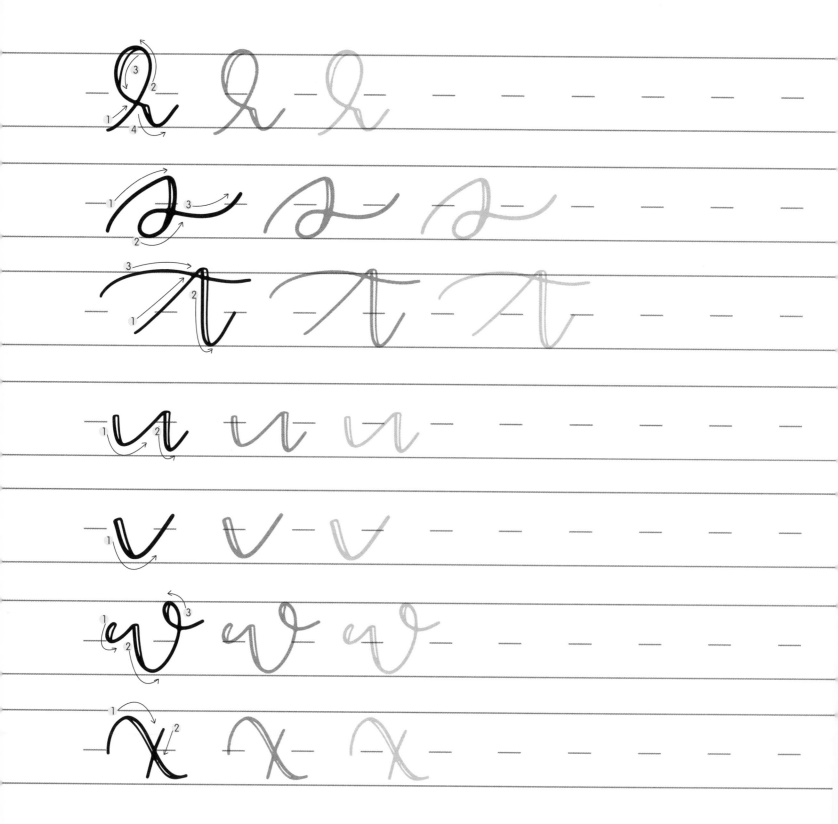

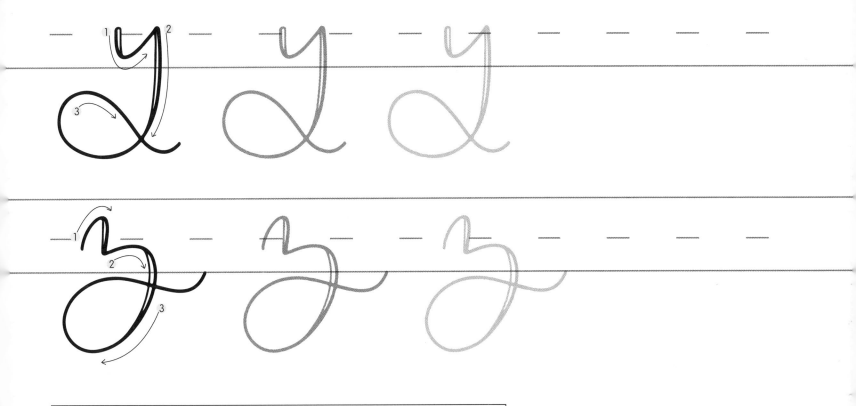

Emma is a little different than the other two alphabets we have worked through. She has wider and longer tails that require more breaks in-between the letters. You can see that I try to keep each tail at the same 45ish degree angle outward before I start the next letter. This gives Emma a more consistent and clean look. She's definitely becoming a go-to when I want something a little more elegant and free.

connect the "t" to the "s" by extending the "s" tail and starting the downstroke of the "t" where it hits the tail of the "s"

keep the tail angle consistent

connect the "y" to the "a" by extending the "a" tail and starting the "y" where it hits the tail of the "a"

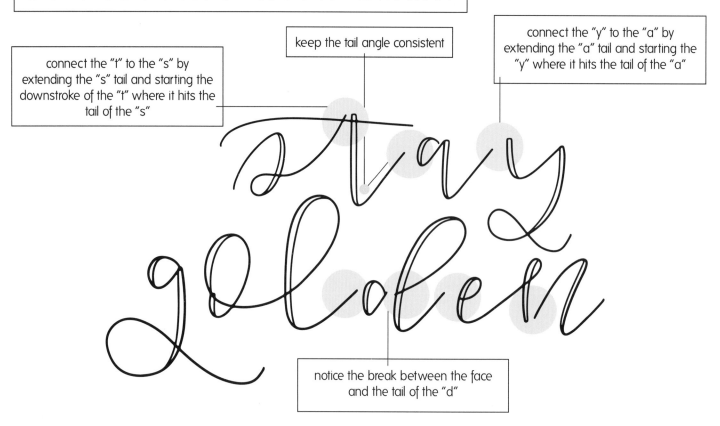

notice the break between the face and the tail of the "d"

Trace the connecting movements here:

 Use the space below to practice connecting with the Emma Alphabet!

the

alphabet

Kate is the sister to the Sarah Alphabet. She takes on a different feel with a monoline look, sleek + sophisticated.

recommended pen: Micron 05 or 08

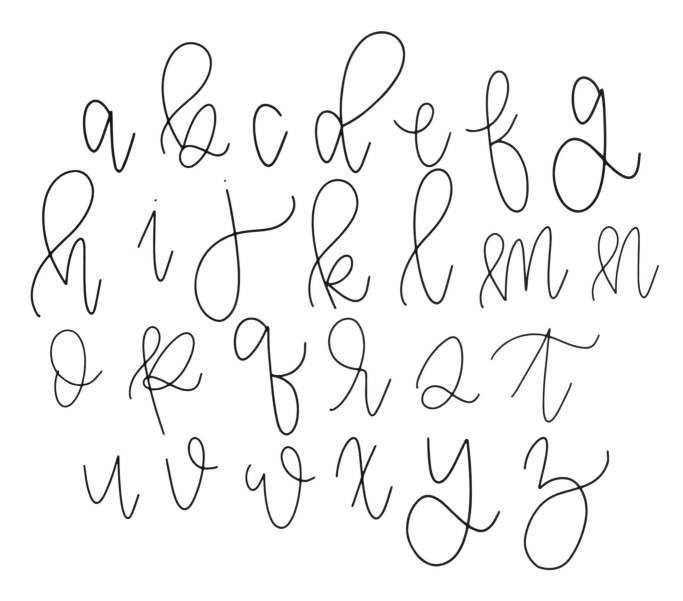

Trace the letter shapes by following the arrows, then use the space to the right to practice on your own!

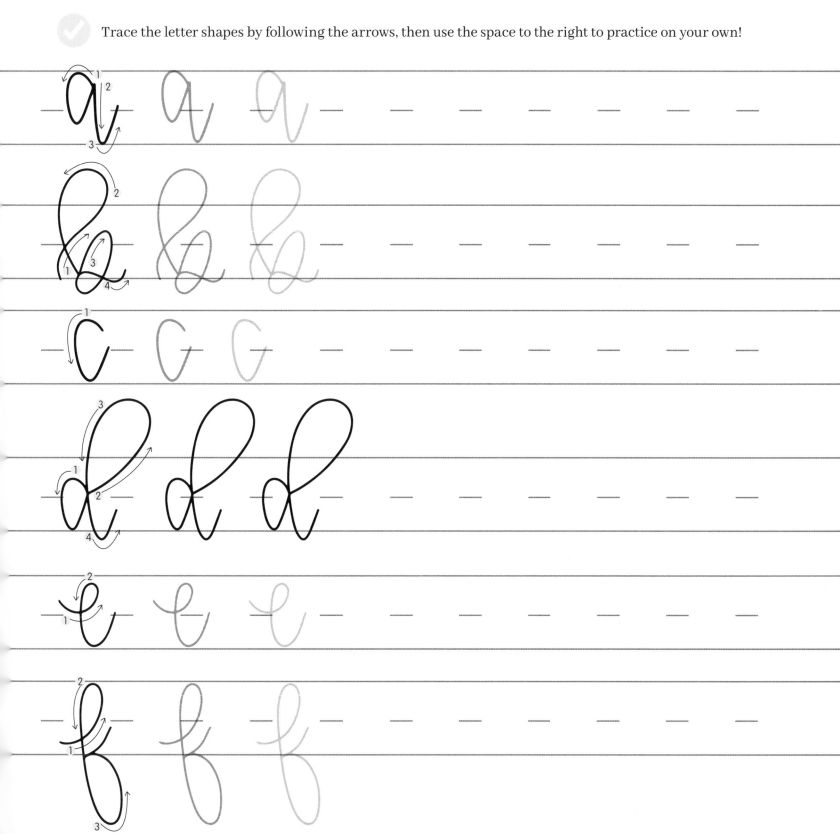

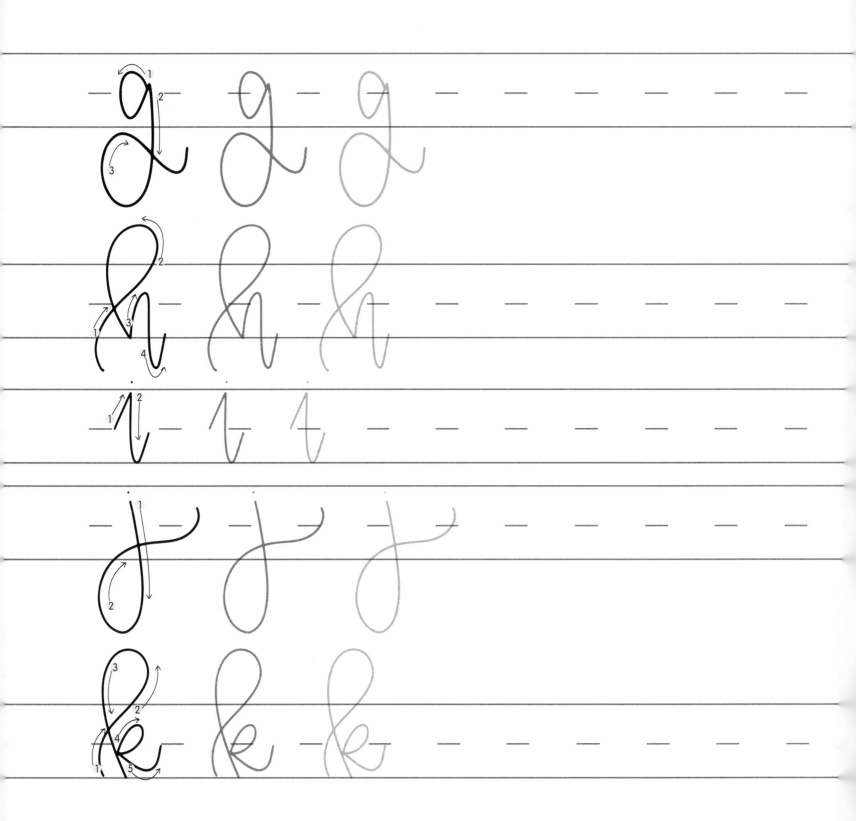

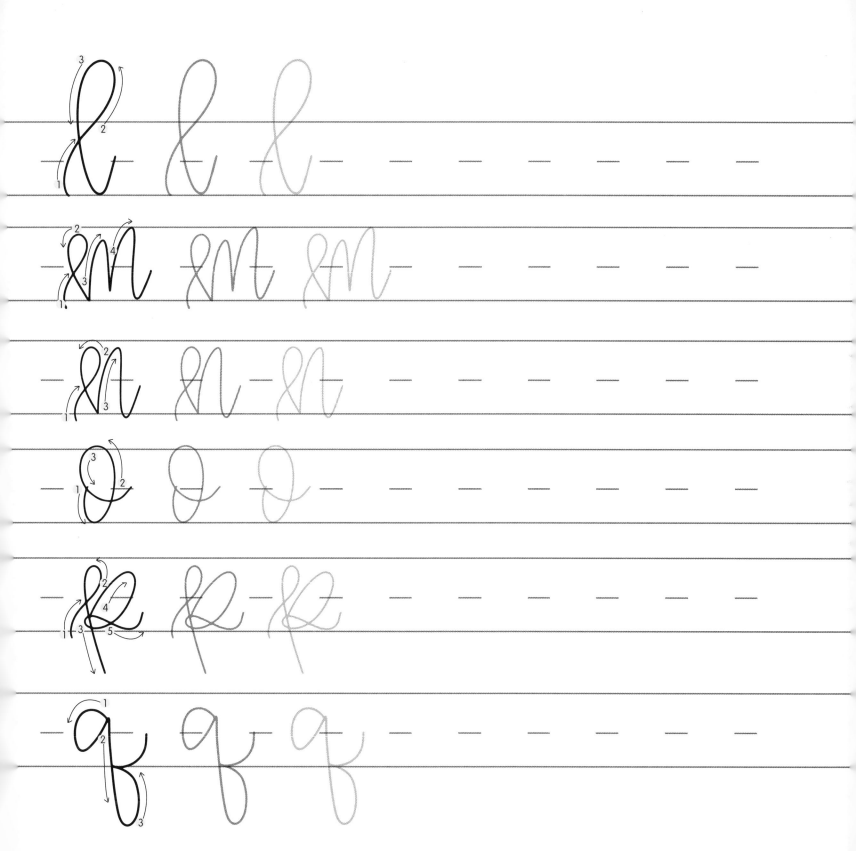

33

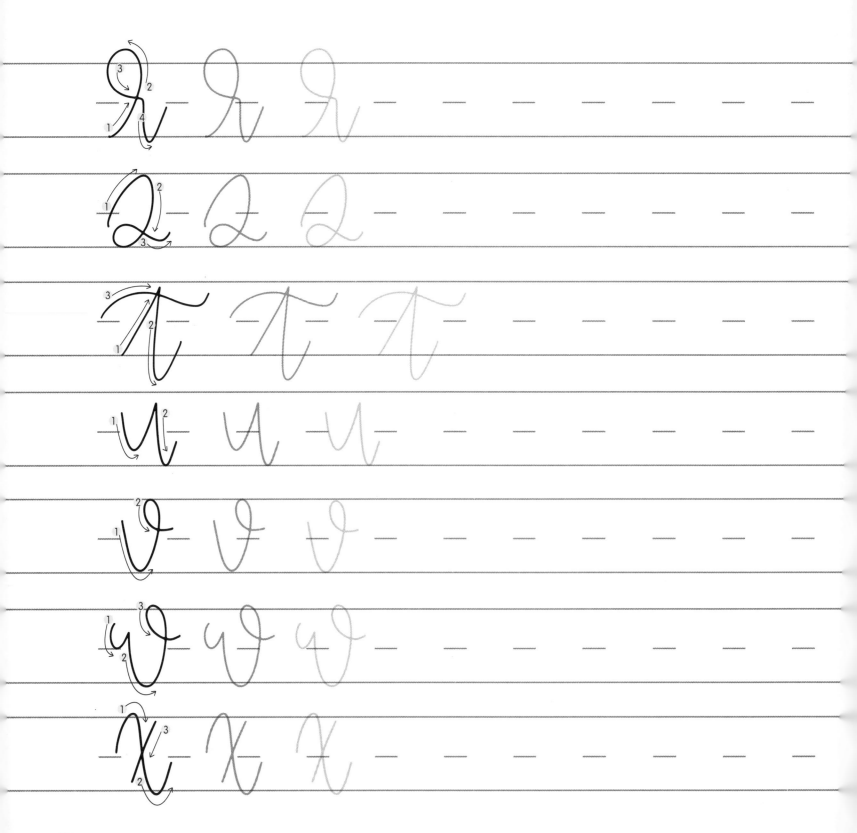

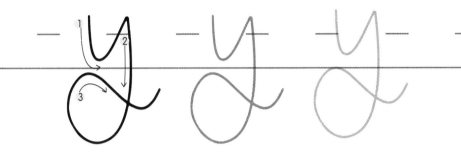

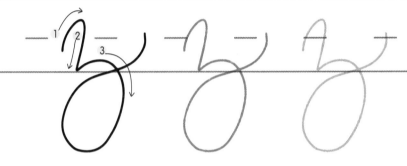

CONNECTING WITH KATE

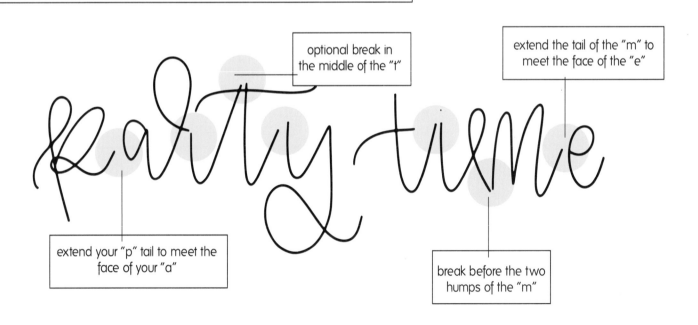

optional break in
the middle of the "t"

extend the tail of the "m" to
meet the face of the "e"

extend your "p" tail to meet the
face of your "a"

break before the two
humps of the "m"

 Trace the connecting movements here:

party time

 Use the space below to practice connecting with the Kate Alphabet!

the *hillary* alphabet

Hillary is a traditional girl with some modern flair. She's slim, pretty, and unique. Remember, use light pressure on your upstrokes and heavy pressure on your downstrokes.

recommended pen: Tombow® Fudenosuke Calligraphy Pen or a traditional pointed calligraphy pen

a b c d e f g
h i j k l m
n o p q r s t
u v w x y z

Trace the letter shapes by following the arrows, then use the space to the right to practice on your own!

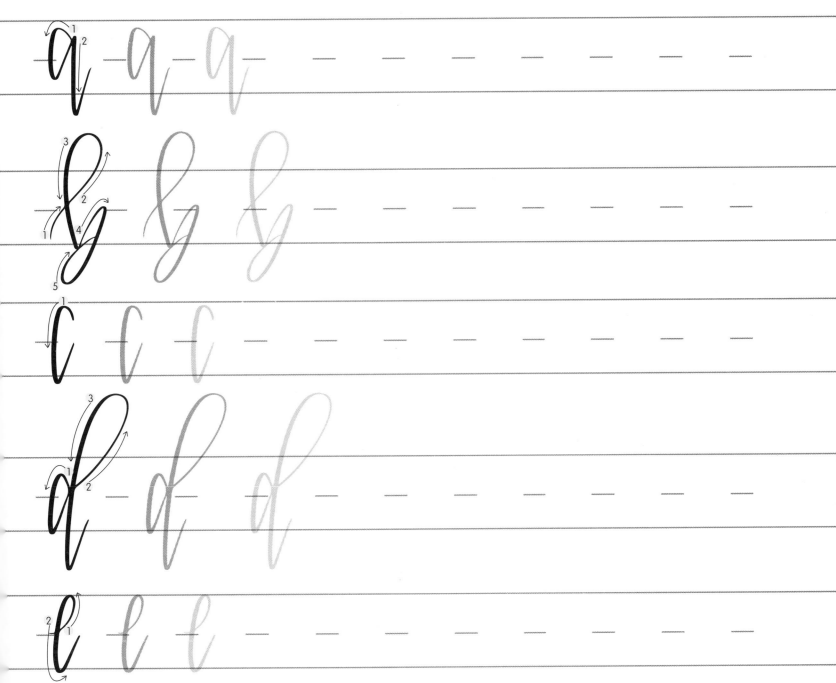

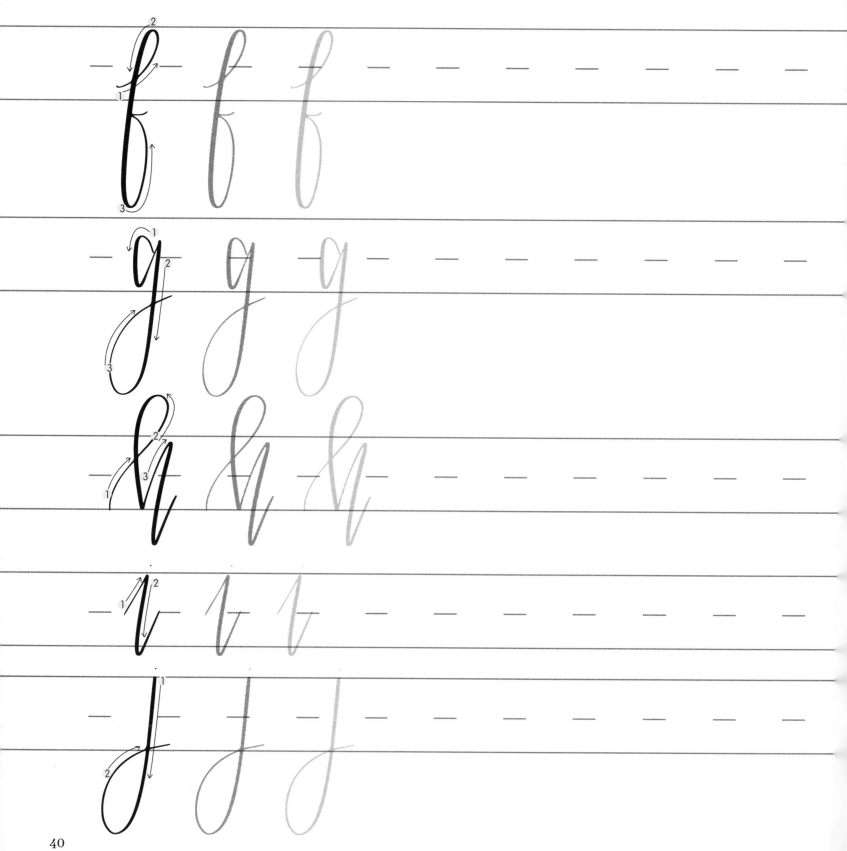

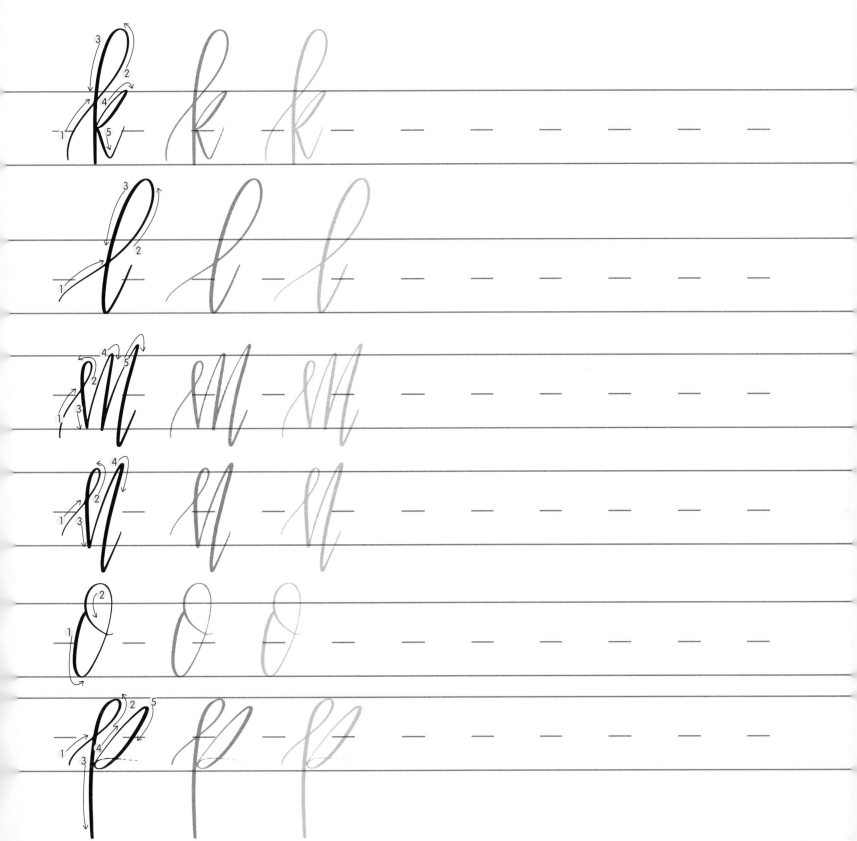

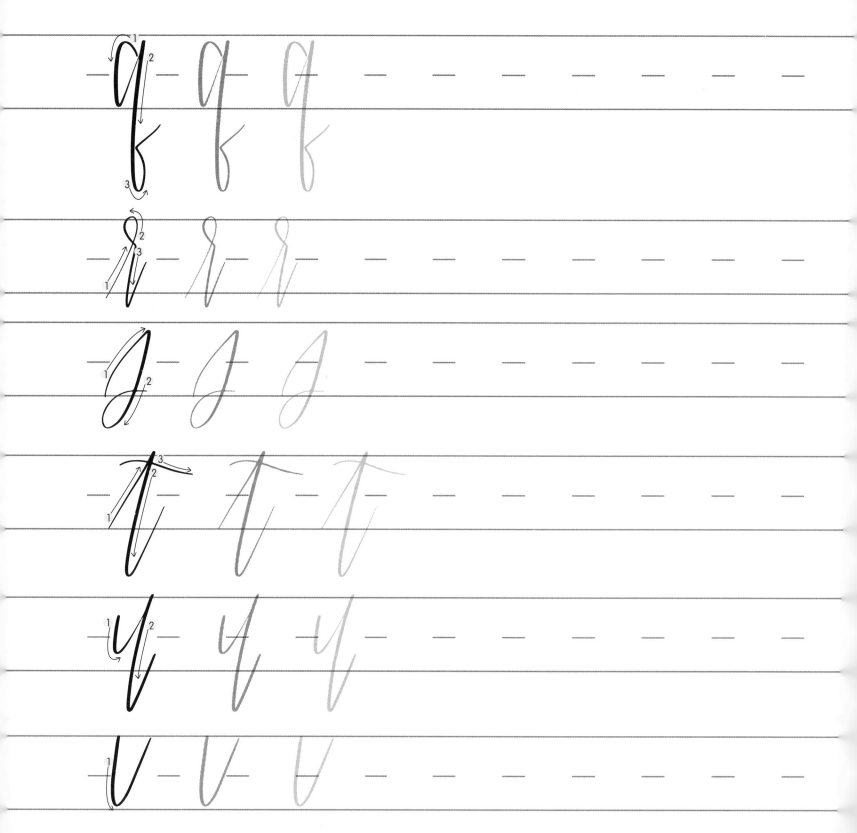

LET'S TALK

I feel like after that one, you'll want to chat. Was it hard for you? It definitely was for me. Stepping out of your traditional comfort zone can have some really beautiful outcomes—just like this Hillary Alphabet. Working with traditional calligraphy pens is still very hard for me. I have to think a lot more about what I am doing. If this was challenging for you, try slowing down, coming at the paper at a stronger angle, and holding your pen more loosely. I find that I concentrate extra-hard on keeping my upstrokes thin and applying consistent pressure on my downstrokes.

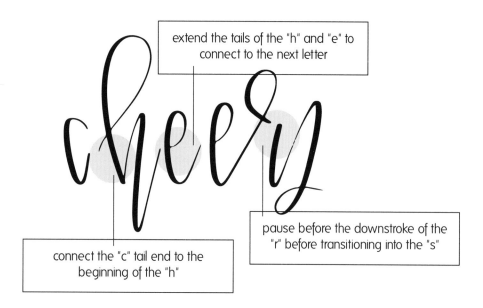

extend the tails of the "h" and "e" to connect to the next letter

connect the "c" tail end to the beginning of the "h"

pause before the downstroke of the "r" before transitioning into the "s"

 Trace the connecting movements here:

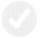 Use the space below to practice connecting with the Hillary Alphabet!

the *alexa* alphabet

Alexa is your modern, hip cousin who is almost too cool for school. She takes on a different look with edgy angles.

recommended pen: Tombow Fudenosuke Calligraphy Pen or Koi® Coloring Brush Pen

 Trace the letter shapes by following the arrows, then use the space to the right to practice on your own!

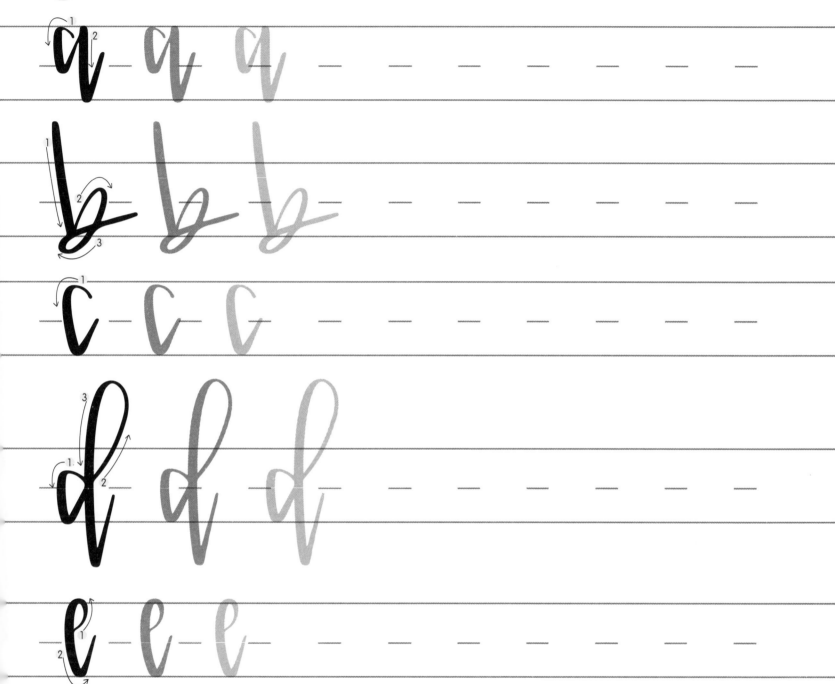

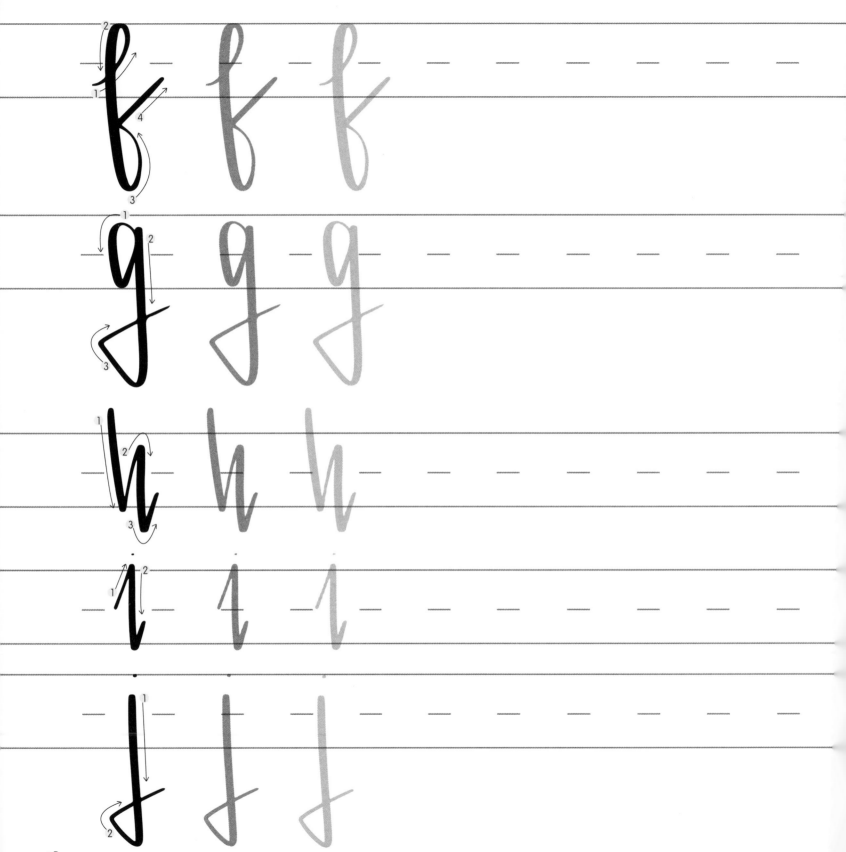

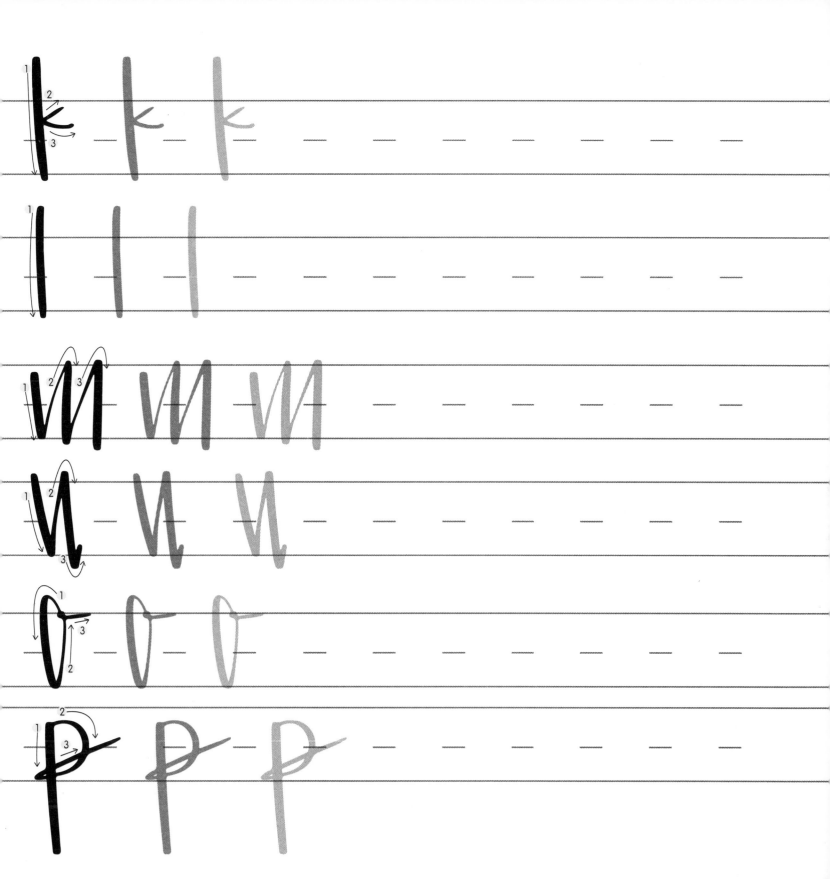

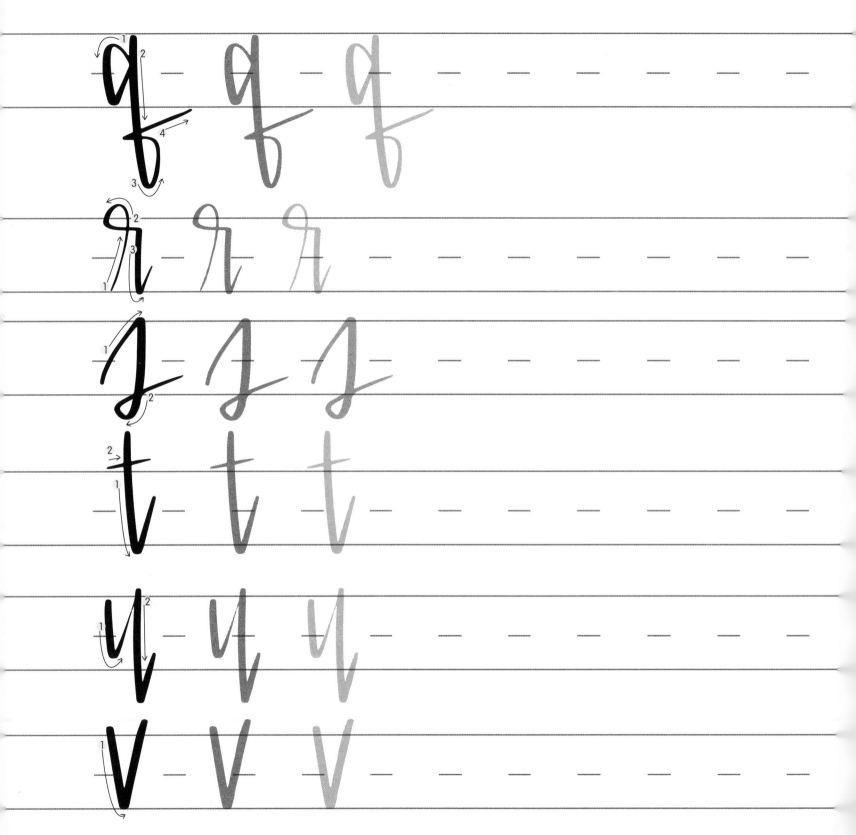

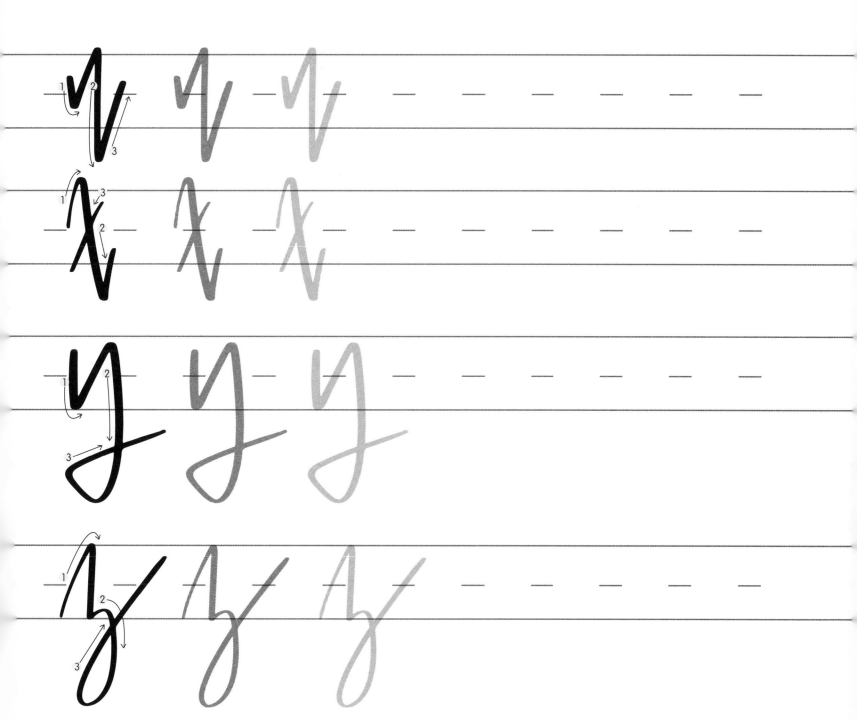

hello hello

The way this alphabet is designed, not all letters will connect! Easy, peasy.

Trace the connecting movements here:

hello

 Use the space below to practice connecting with the Alexa Alphabet!

the
donna
alphabet

Donna is the sweet mom to the Sarah Alphabet, and the unveiling of the much-anticipated capital letters. Maybe you just skipped straight to Donna. I won't judge!

recommended pen: Micron Pen 05 or 08

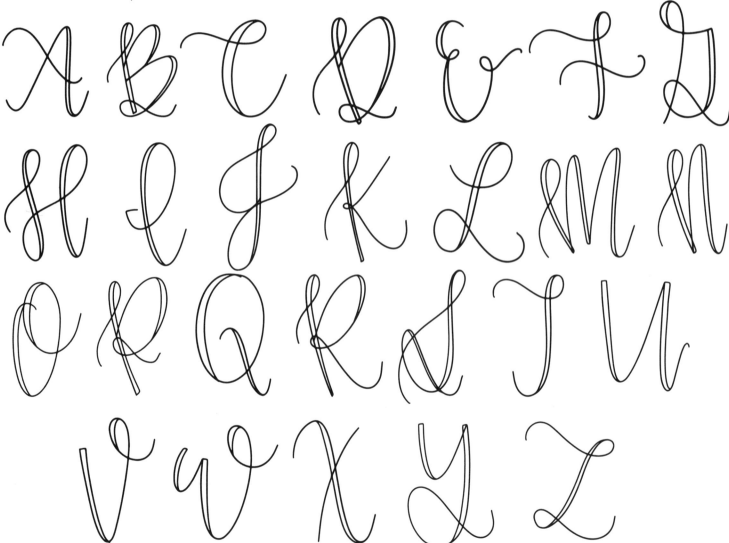

 Trace the letter shapes by following the arrows, then use the space to the right to practice on your own!

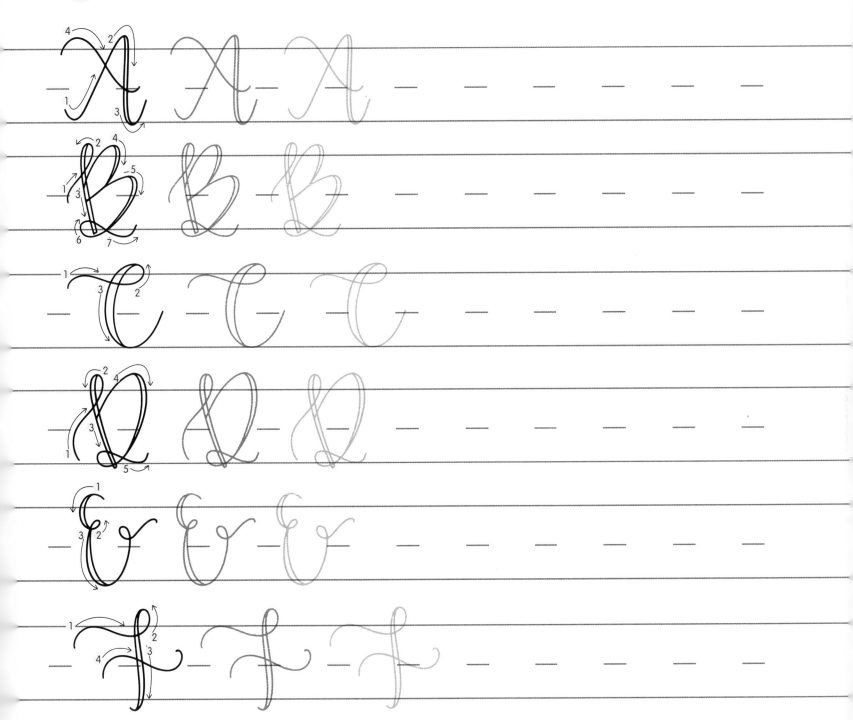

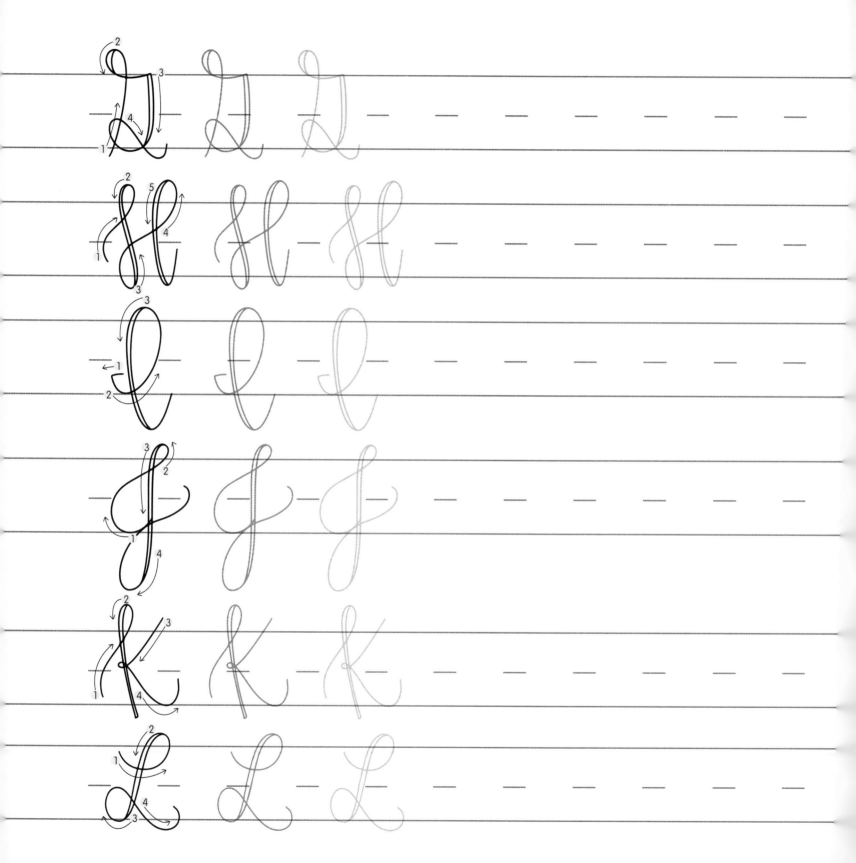

56

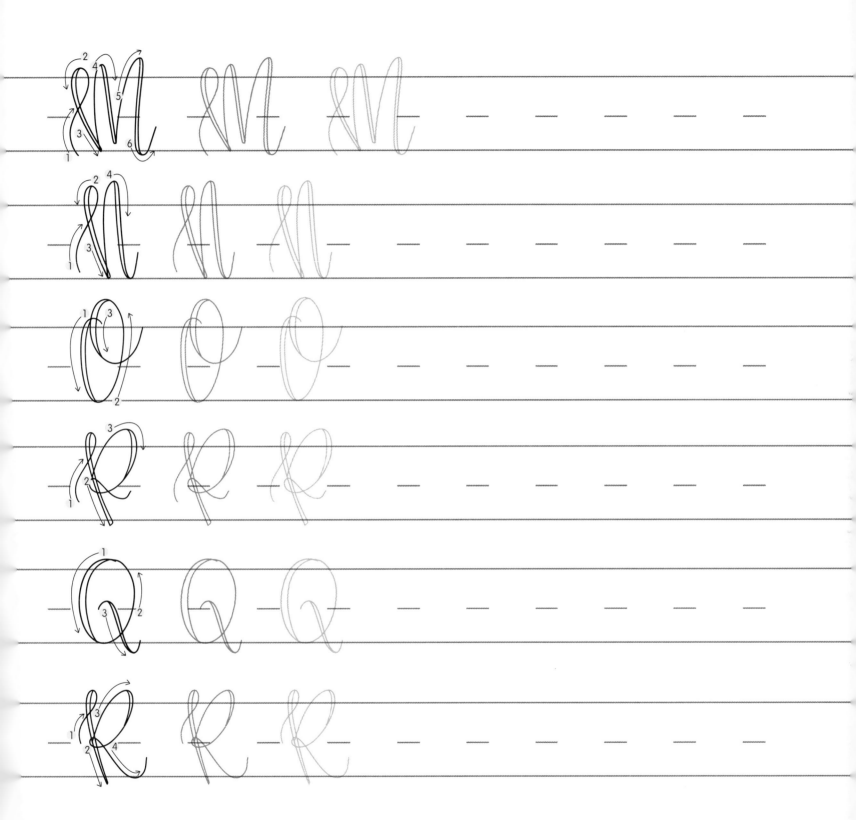

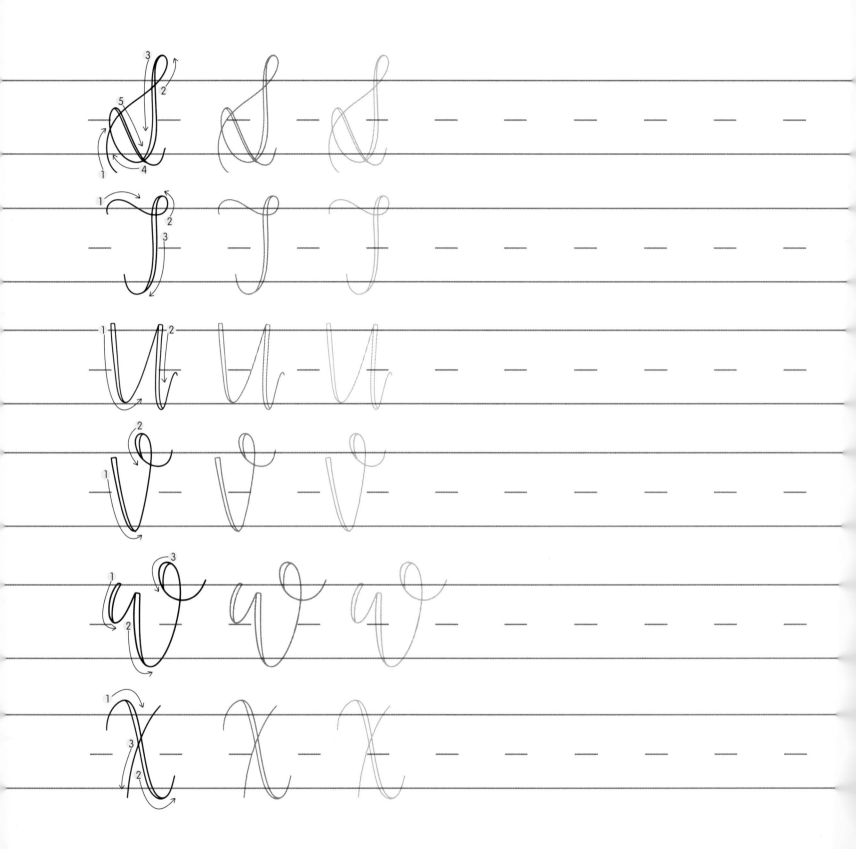

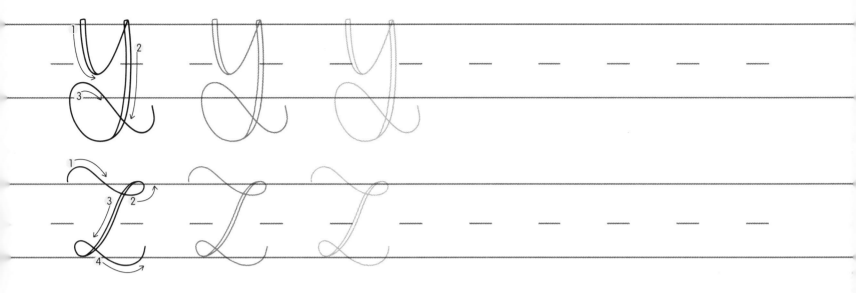

CONNECTING WITH DONNA

When a word begins with a capital letter (such as a name), I usually draw the capital letter alone. The remaining letters are not connected to the capital letter. However, I do make an exception for "Mrs." And "Mr." See the examples below.

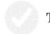 Trace the connecting movements here:

Mrs. Laura

 Use the space below to practice connecting with the Donna Alphabet!

the

alli

alphabet

Alli is the older sister to Hillary: a modern + elegant take on the uppercase alphabet. Remember: only apply pressure on the downstrokes!

recommended pen: Tombow Fudenosuke Calligraphy Pen or a traditional pointed calligraphy pen

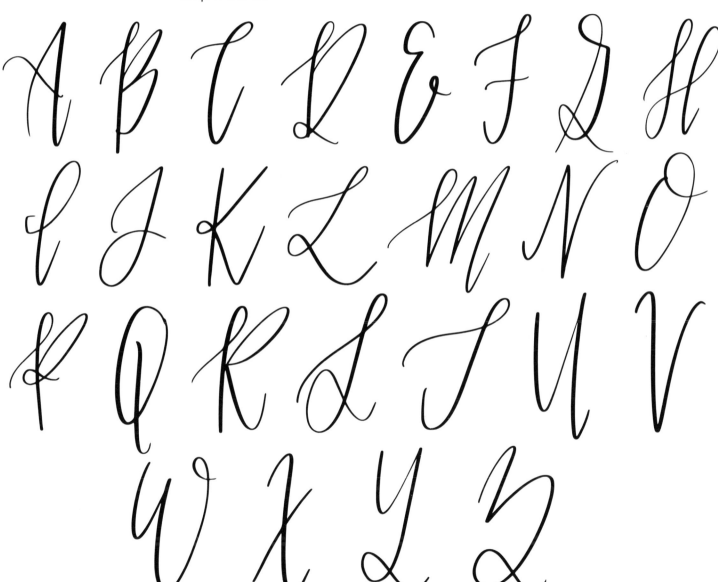

 Trace the letter shapes by following the arrows, then use the space to the right to practice on your own!

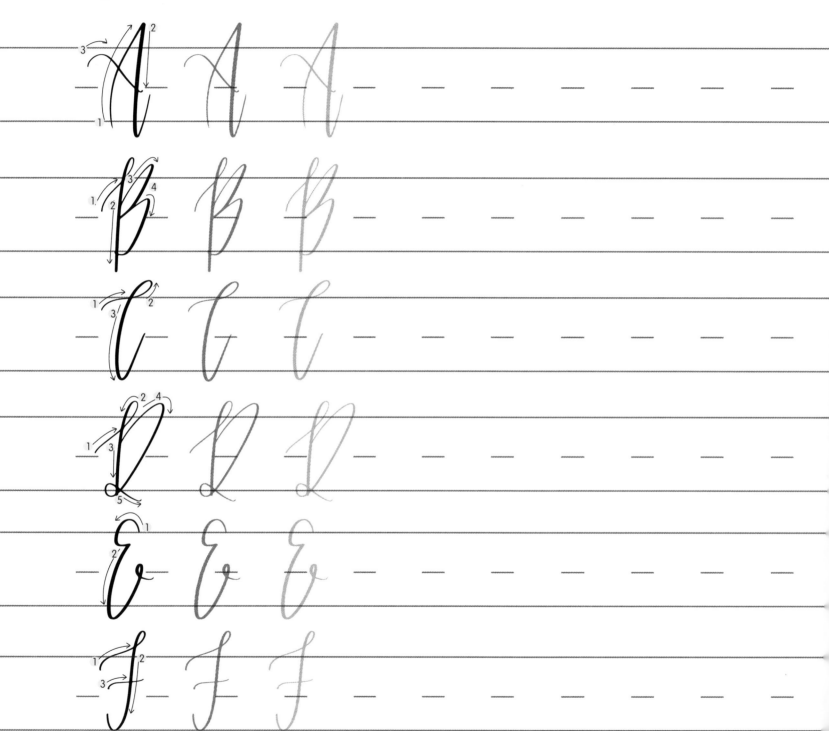

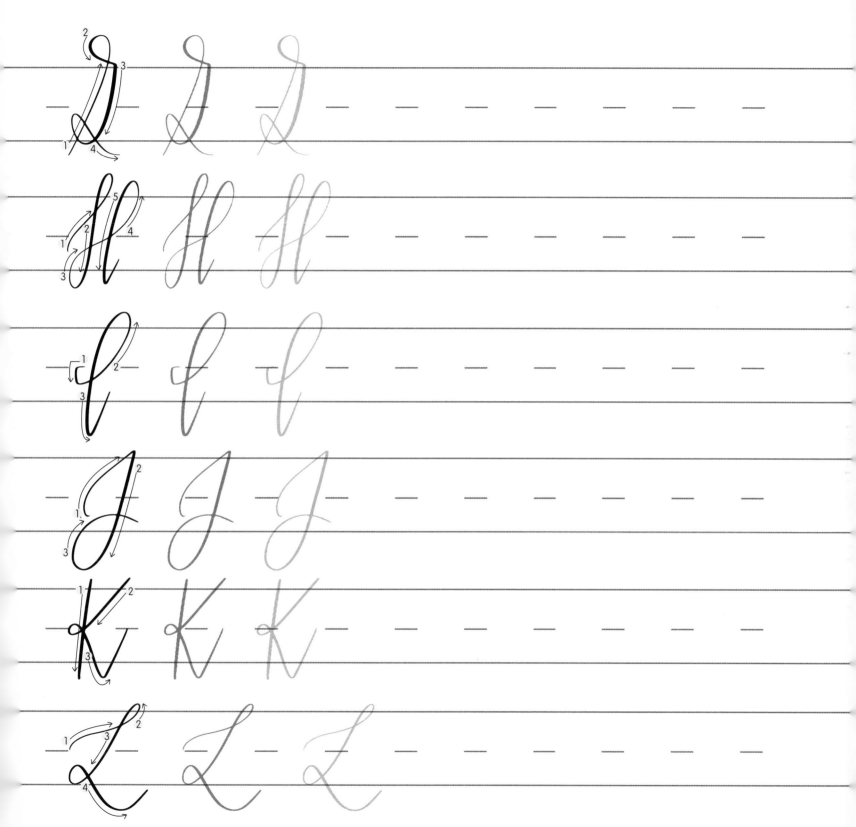

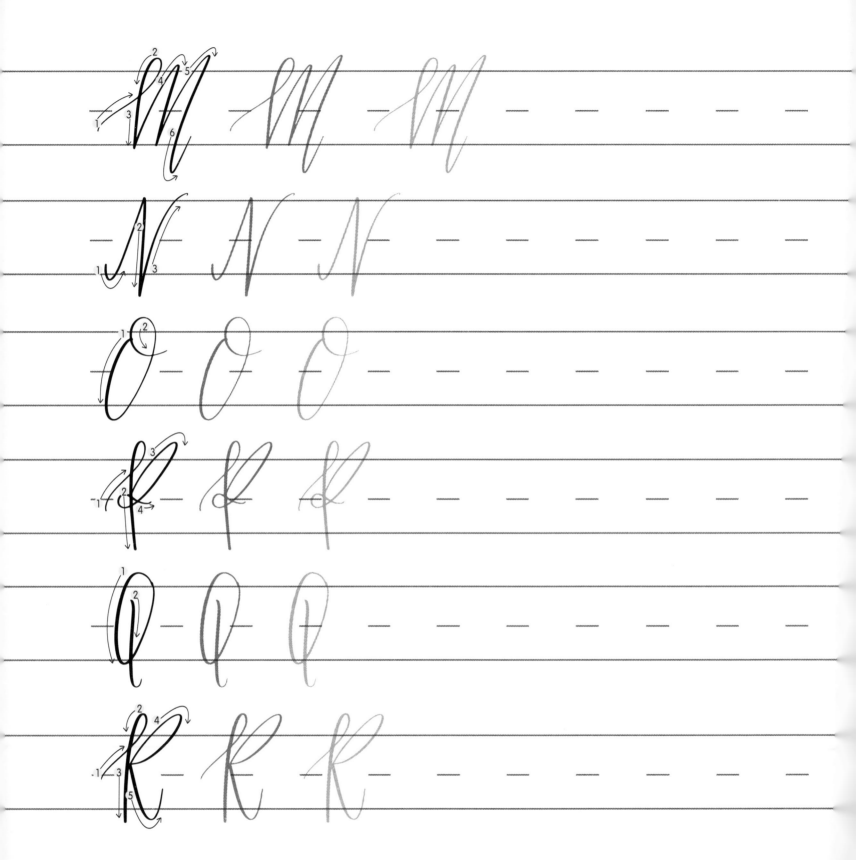

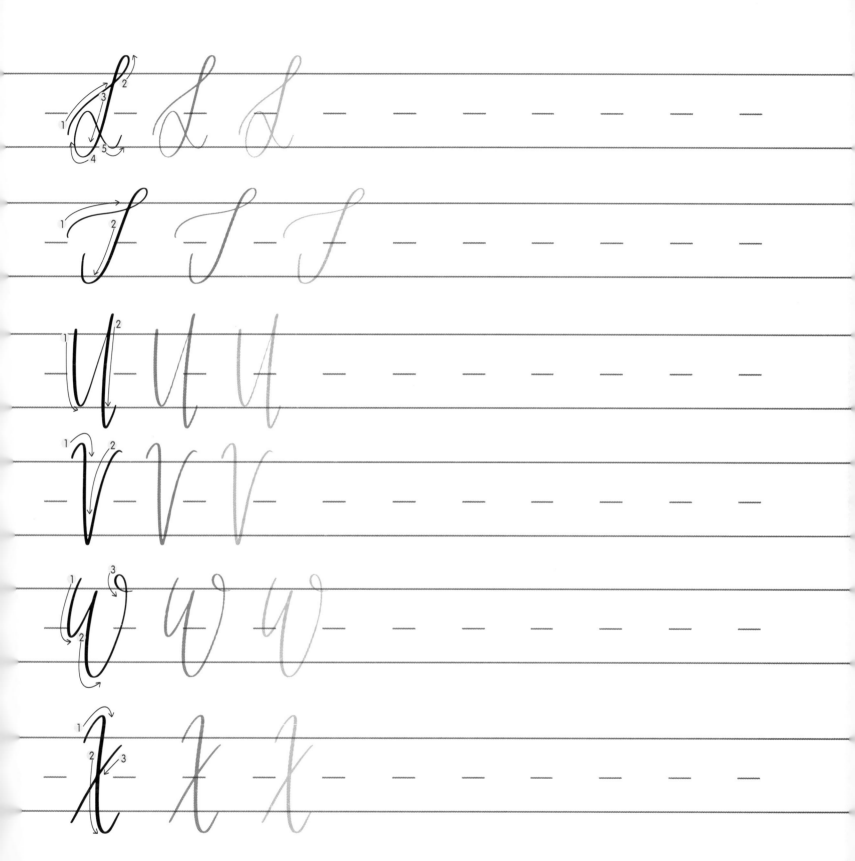

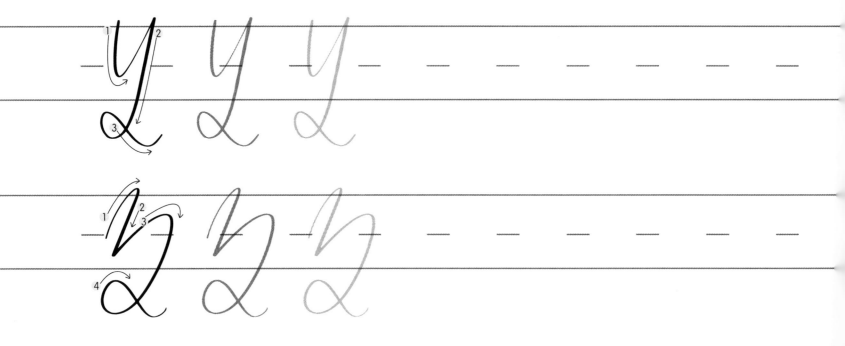

CONNECTING WITH ALLİ

With Alli, I do not connect between the uppercase and lowercase letters.

Trace the movements here:

Name Laura

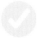 Use the space below to practice with the Alli Alphabet.

the *meg* alphabet

Meg is a cutesy, hand-lettered serif alphabet. She is the perfect addition to the Sarah Alphabet or Jill Alphabet.

recommended pen: Micron Pen 05 or 08

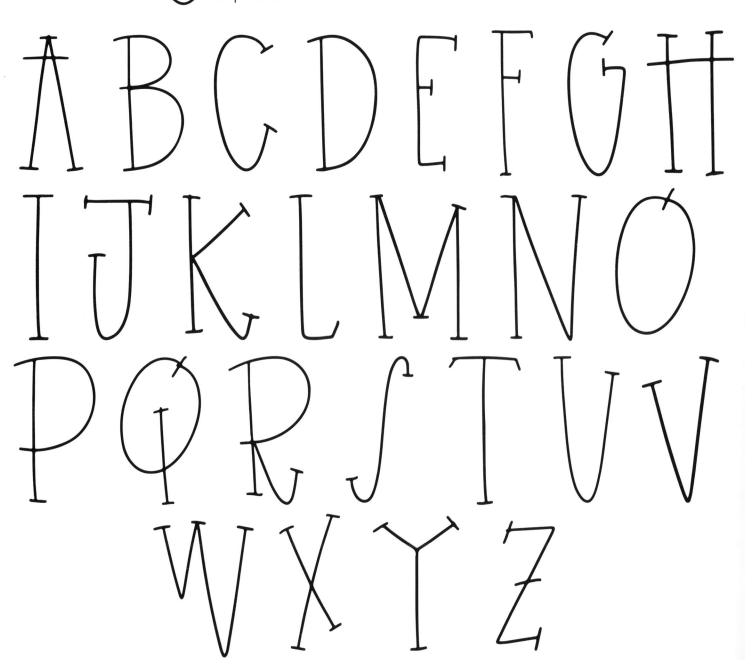

Trace the letter shapes, then use the space to the right to practice on your own!

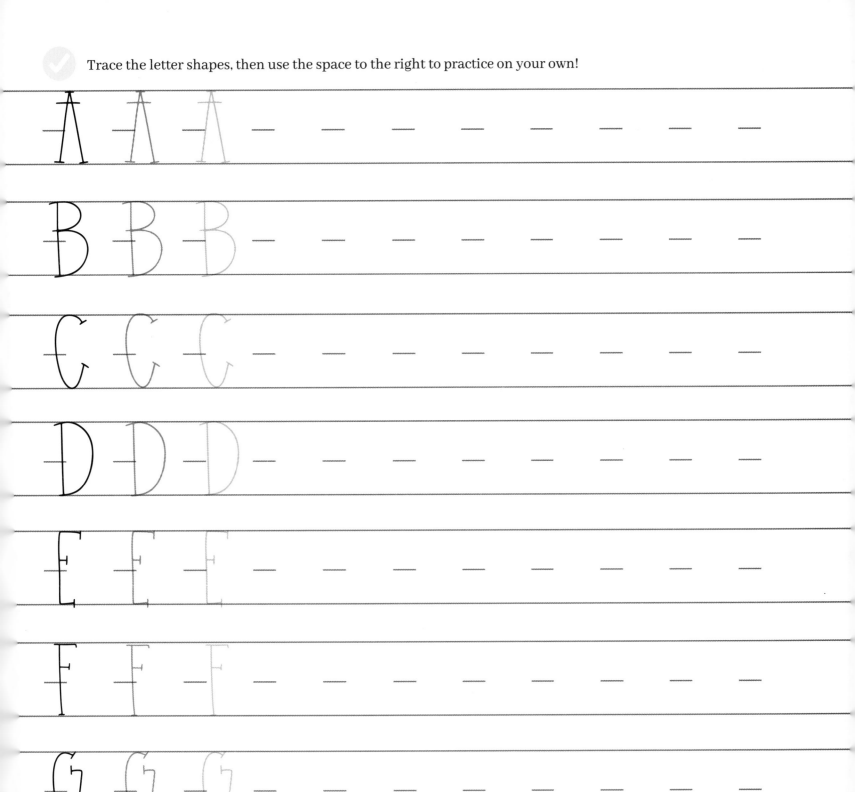

 Use this page as a reference! Feel free to trace the letters to get a feel for their forms.

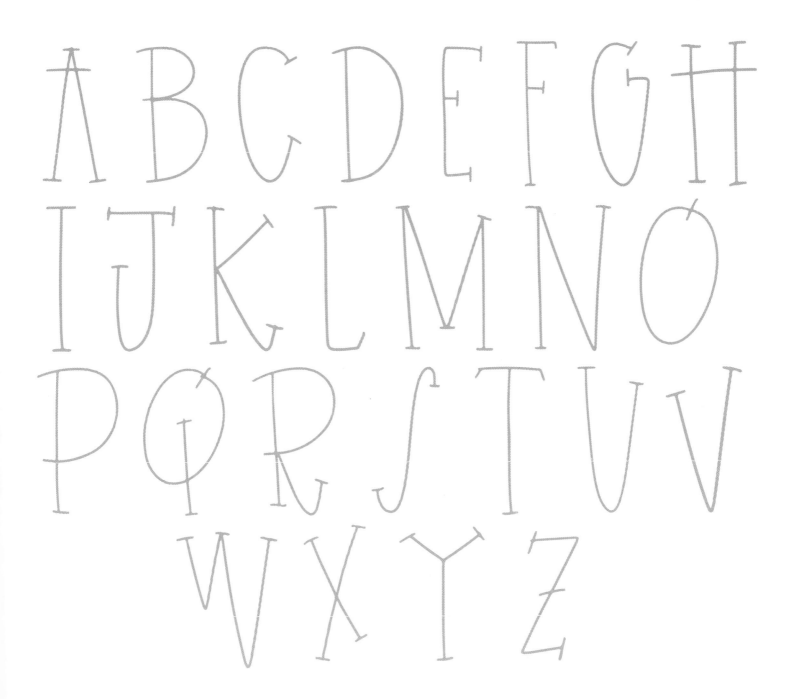

the
kiely
alphabet

Kiely is a tall and skinny lady who can be dressed up or down. Her elegant simplicity adds a modern touch to any alphabet pairing.

recommended pen: Micron Pen 05 or 08

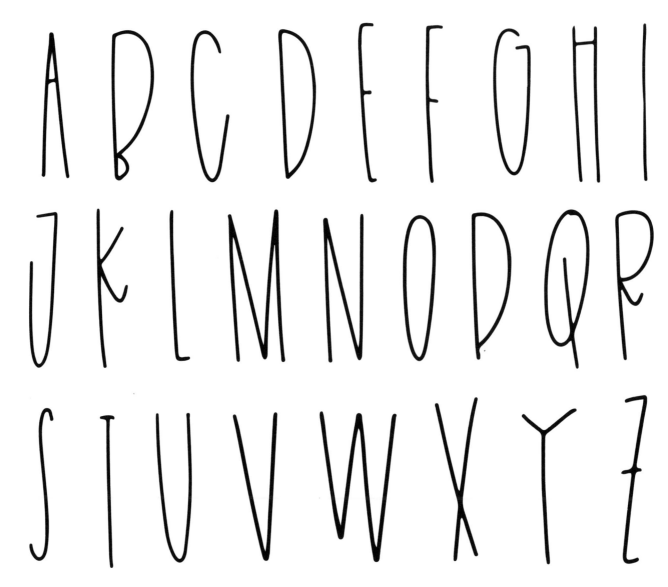

Trace the letter shapes, then use the space to the right to practice on your own!

A A A

B B B

C C C

D D D

E E E

F F F

G G G

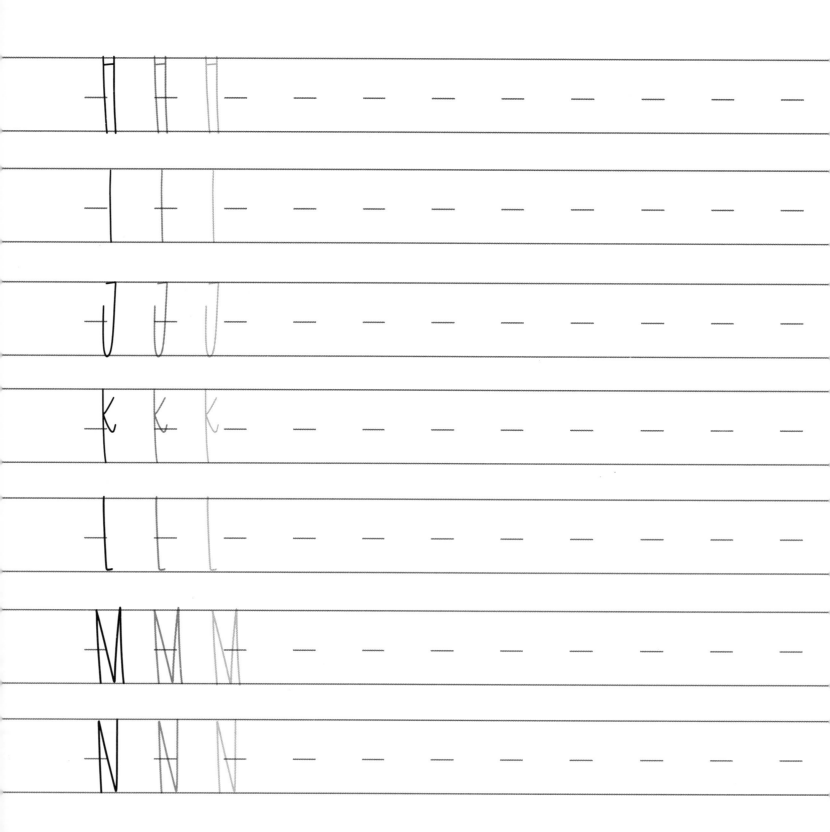

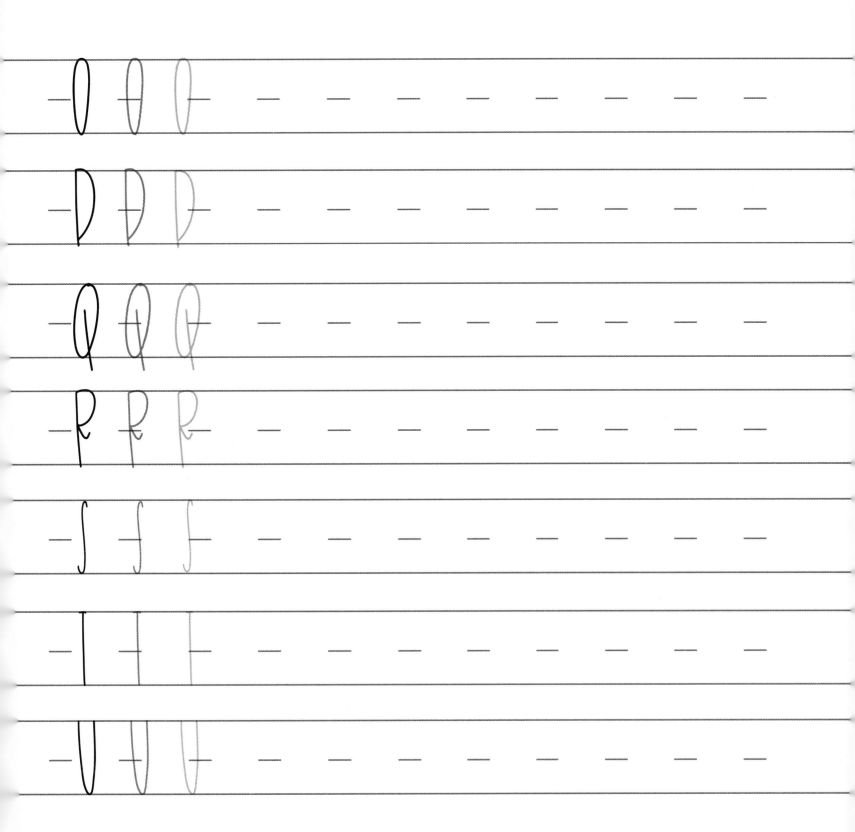

V V V — — — — — — — — —

W W W — — — — — — — —

X X X — — — — — — — — —

Y Y Y — — — — — — — — —

Z Z Z — — — — — — — — —

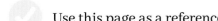

A B C D E F G H I

J K L M N O P Q R

S T U V W X Y Z

the *tilly* alphabet

Tilly is wild + free—her cuteness can't be tamed. Pair her with Jill or Emma for an extra funky combo!

recommended pen: Micron Pen 05 or 08

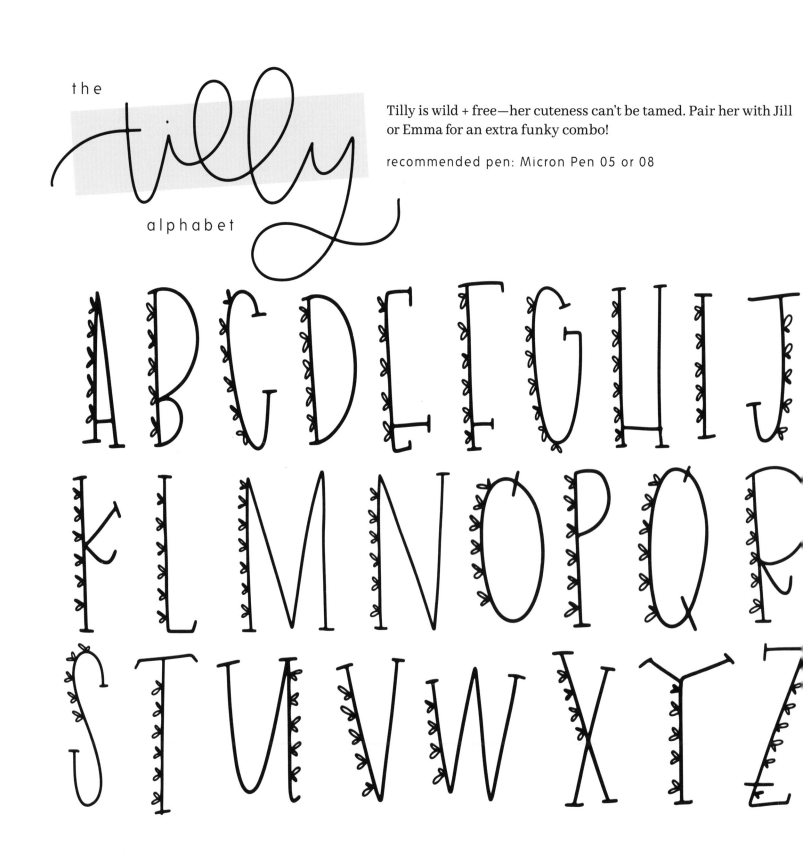

Trace the letter shapes, then use the space to the right to practice on your own!

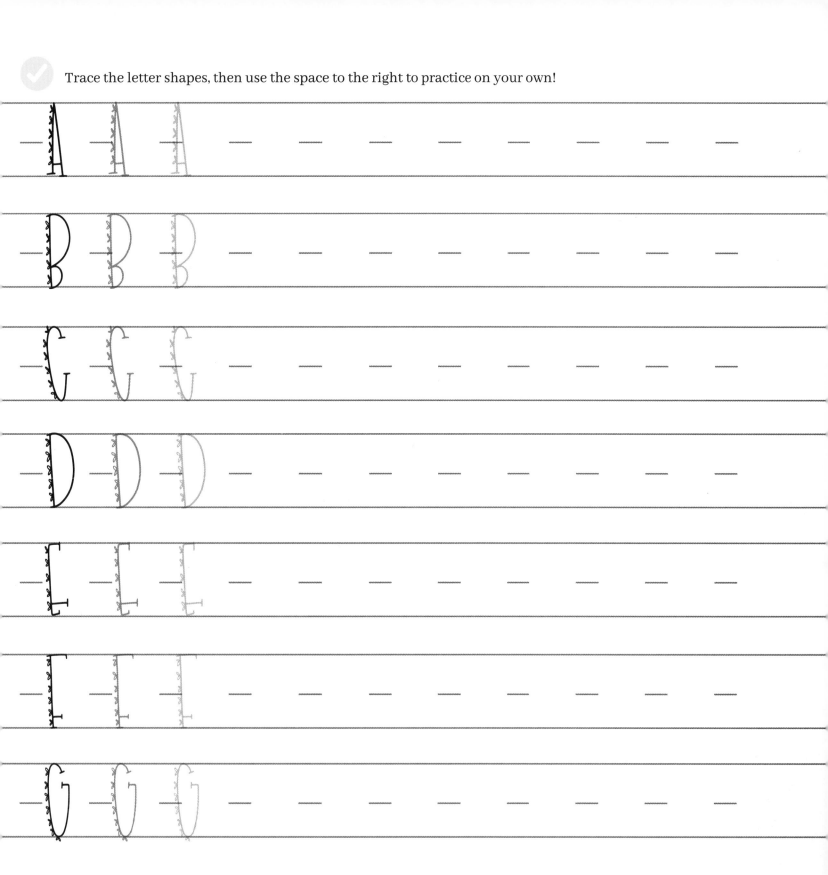

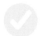 Use this page as a reference! Feel free to trace the letters to get a feel for their forms.

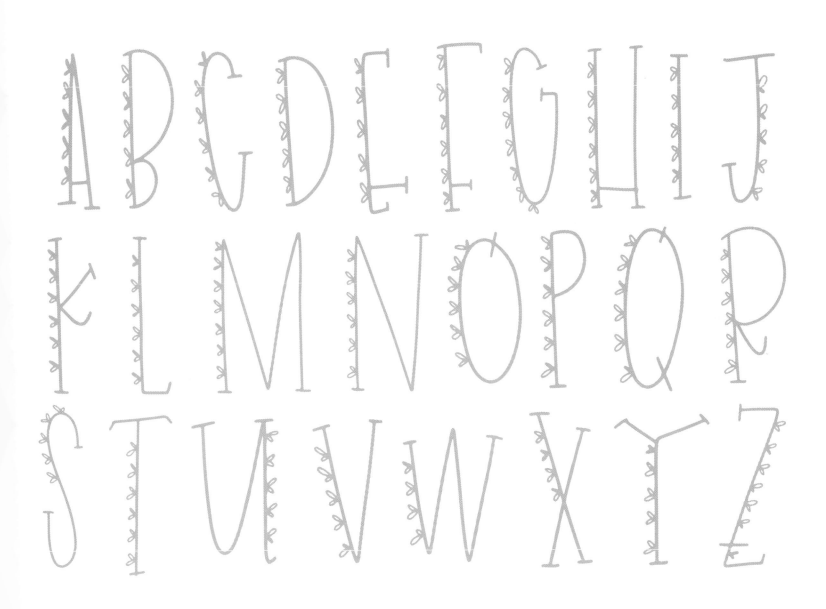

morgan

Morgan is Meg's little sister and adds just the right touch of adorable to any project!

recommended pen: Micron Pen 05 or 08

a b c d e f g h i

j k l m n o p q r

s t u v w x y z

Trace the letter shapes, then use the space to the right to practice on your own!

U U U — — — — — —

V V V — — — — — —

W W W — — — — —

X X X — — — — —

Y Y Y — — — — —

Z Z Z — — — — — —

Use this page as a reference! Feel free to trace the letters to get a feel for their forms.

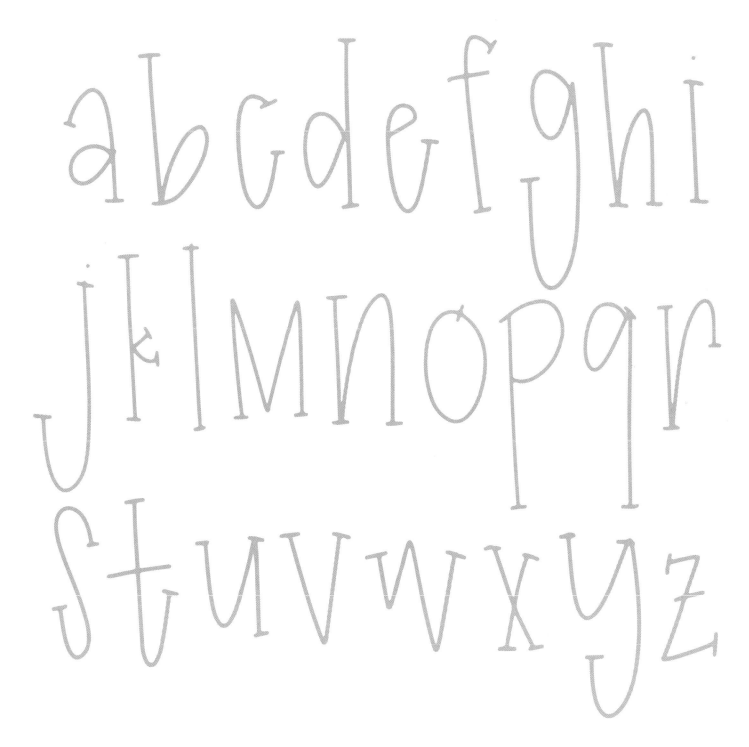

amsterdam

london

tokyo

singapore

paris

istanbul

los angeles

new york

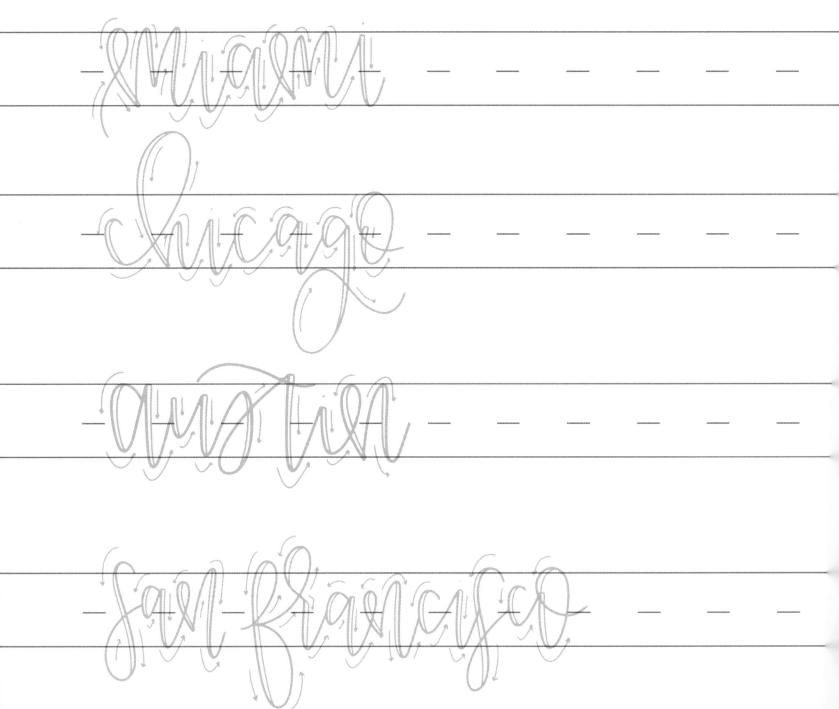

wedding

groom

bride

guest book

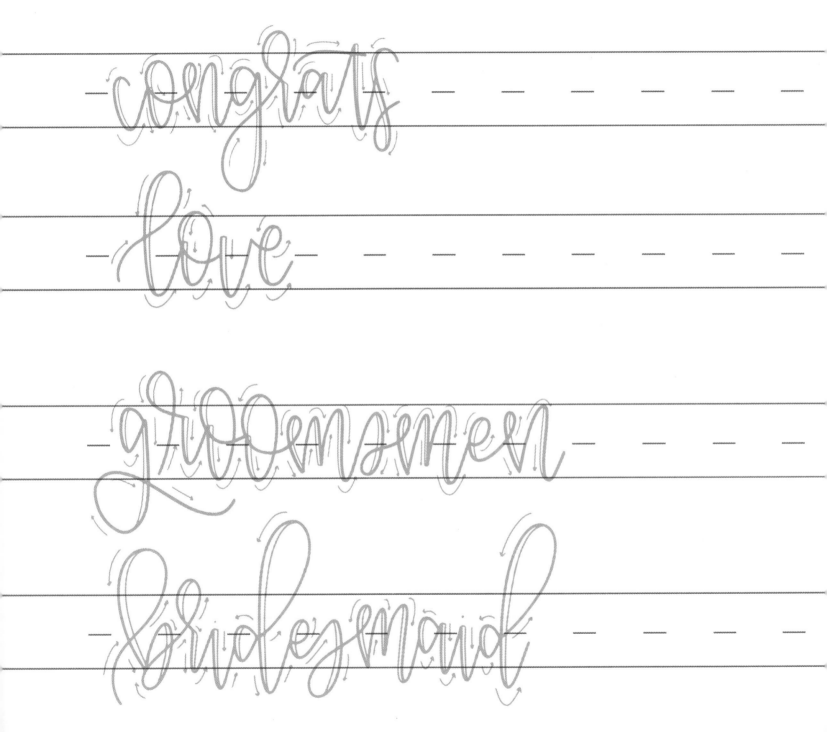

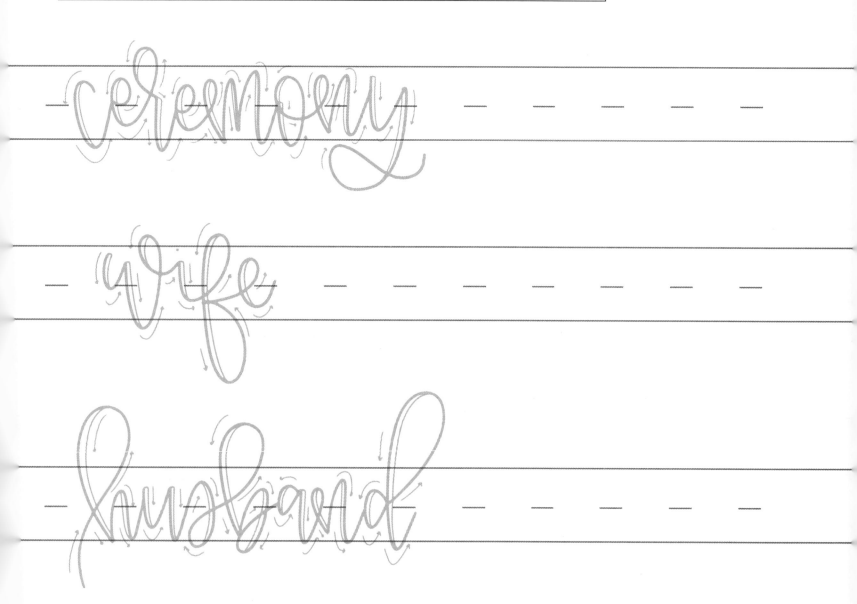

ceremony

wife

husband

PART TWO

Art is not what you see, but what you make others see.
— Edgar Degas

You are feeling confident with your lettering: you can manipulate it, you can use different tools, and you can evoke different feelings. But, you find yourself wanting to do more. You want to create your own pieces. Maybe you want to start a career with your lettering. It is so important to understand the basics of design if you want to do anything like this with your newfound love of letters.

We all see and interpret design differently, and I think that is beautiful! It is your job as the designer to communicate meaning and evoke certain feelings from the viewer. There are many ways to do that. Let's discuss further!

HIERARCHY

Hierarchy refers to the way your visual elements talk to and complement each other. When we look at anything—take this book for example—there are ways we can prompt the viewer to start with the title of the section, flow through the paragraph, and end with the examples, all using the hierarchy of the design. The viewer intuitively recognizes where to start and where to end on the page because visual elements guide them through the journey. As viewers becomes familiar with the order, it becomes easy for them to understand and read similar pages. The way designers use hierarchy helps to organize the content and enhance the design.

This concept can be implemented with lettering or typography using placement, space, scale, stroke thickness, and different typefaces.

You may already be familiar with negative or white space within a design. Space is incredibly important, and it can be a powerful tool to help someone know how to navigate a design. Space creates a pathway for the eye, and helps to direct focus on the important elements of a design.

Scale is another obvious and easy way to create hierarchy within our typographical designs. When both small and large elements are combined, a natural contrast is created, giving the eye something to focus on.

Typeface/Typography also creates hierarchy. Choosing the right typeface is key for what you want your design to convey. Remember: you want to keep the number of different typefaces within a design to a minimum, usually no more than three. The more typefaces that are introduced, the more confusing a design can become. A few key rules to ensure legibility: never use a hand-written font in all caps, and remember that serif lettering tends to be the most legible.

Another thing to consider is whether you will feature any other visuals in your design: graphic shapes, linear elements, doodles, flourishes, or photographs. These can enhance the primary content of the design and draw in the eye of the viewer.

CLASSIFICATION OF TYPEFACES

× Old Style

× Transitional

× Modern

× Sans Serif

× **DISPLAY**

× Slab Serif

× *Script*

Additionally, the classifications above are the main ones and will be a great reference point for choosing typefaces to use in your design. Font websites like www.fontsquirrel.com (my personal favorite!) or www.dafont.com show typefaces broken down even further into different classifications.

EXAMPLE OF HIERARCHY

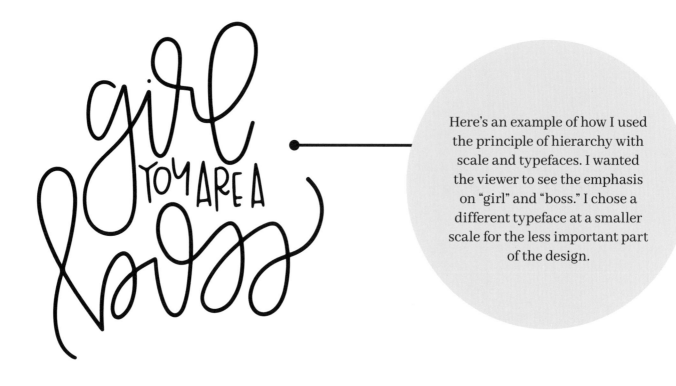

Here's an example of how I used the principle of hierarchy with scale and typefaces. I wanted the viewer to see the emphasis on "girl" and "boss." I chose a different typeface at a smaller scale for the less important part of the design.

DESIGN PROCESS

The design process is different for each person. But, when you are just starting out or if you are struggling, it is nice to have a framework to fall back on. Let's dive deeper into a design process workflow:

Brainstorm - Conceptualize - Experiment - Execute

BRAINSTORM

Think about your final design or project. What do you want it to say? Are you inviting, informing, promoting, amusing, explaining, or igniting creativity?

Once you decide what you are trying to accomplish, it is your job as the designer to be the problem-solver. For example, how are you going to amuse people?

Inspiration is the key to the brainstorming stage. We designers and creatives are visual people by nature, and we need to exercise our creativity to stay inspired. We can do this by reading books or magazines, looking at vintage design, and surrounding ourselves with culture, architecture, and art. When seeking inspiration, you might not see precisely what others see, and that's the beauty of it! We all take in things differently. It is important to be observant, attentive, and open-minded. Inspiration should feel natural, not forced. Find an organized way to save your inspiration: writing in a journal, drawing, taking photos, pinning on Pinterest, or any other method that works for you!

When you are looking for inspiration, it's important to remember that you are grabbing elements and feelings from different designs, but not copying them.

An easy way for me to brainstorm is to find key words to describe the project. Some examples might be: vintage, modern, clean, messy, organic, natural, or busy. What do you want people to feel? Do you want them to feel happy, intrigued, empowered, inspired, or even angry? Once you nail down some key words, it's easy to return to those words and ask: "Is this design making me feel empowered? Why? Will it make the end viewer feel the same way?"

CONCEPTUALIZE

Once you have answered questions, gathered inspiration, and put some ideas on paper, it's time to move from brainstorming to conceptualizing your final design. Since we are learning about typography + lettering, we have to think about what kind of type and/or letterforms will be used. What tools will best convey your intended meaning? In this stage of the process, it is great to start roughly sketching out your design, either in your head or on paper. Once you feel like you have the concept thought out, you get to move on to the fun stage.

EXECUTE

You have experimented and sketched out your final design. It evokes the feeling you want and you are really happy with it! Now it is time to execute! Your workflow from this point will depend on your specific project. You might be taking your design and finalizing it on a computer, or putting chalk to a chalkboard.

> Fail, fail again, fail better.
> - Samuel Beckett

COLOR

You will be amazed by how much color influences your final design. Let's go back to the key question: what kind of feelings are you trying to evoke? Different colors are interpreted differently when mixed and matched. It is common to gravitate toward similar colors with each project. It's human nature: we like what we like! This is great when you are working within the same brand and you can stick to the color guidelines you set up to create a consistent and put-together look. But, if you are designing for different customers or businesses, it's crucial to choose the correct colors for the project at hand!

Remember when I said that certain colors evoke certain feelings?

Think about primary colors, pastel colors, and neutrals. What kinds of things come to mind? There are some very basic color correlations. For example, red is often associated with anger, or passion. Blue is calming. Yellow is bright and cheerful. There have been many studies on how to use color in design. For example, in web design, people are more likely to click a blue button than any other color. Therefore, a blue "call to action" button should result in more clicks!

After I have a loose sense of the kind of colors I want to use in a design, I usually play with the color wheel in the design program I am using. I whittle down to my final 3-4 colors. If it's relevant, I can grab certain colors from inspiration photos. I create boxes at the top of the design file, off the art board, and fill the boxes with my chosen colors. This makes it easy for me to use the eye dropper tool to grab any of the colors from my palette. If you need a little extra assistance when selecting your colors, there are resources available. For example, try the Adobe® Color tool at www.color.adobe.com. You can play with the color wheel, or even upload an inspiring image to pull colors from. This is an incredibly useful and amazing tool.

Because most of my designs need to align with my brand, I keep the colors I use in the same family. Most of my brand colors are muted + pastels. I want my brand to be modern and timeless, but I also incorporate some of my favorite colors, like blush and mint.

Think of the key words that you want to hit on. Now, try to determine what colors best convey those feelings.

SOME OF MY FAVORITE COLOR PALETTES

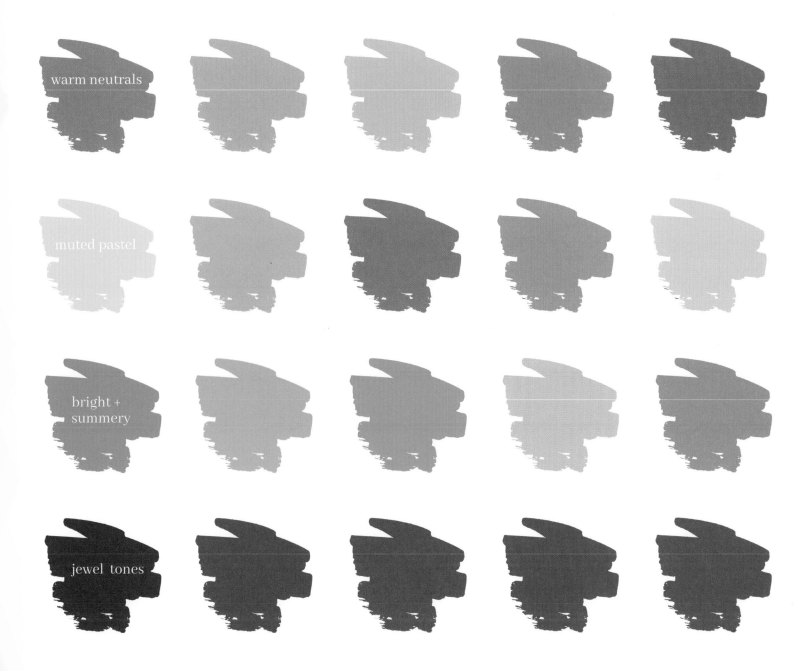

warm neutrals

muted pastel

bright + summery

jewel tones

I started in graphic design in 2006 and began lettering in 2013; it's amazing how much things have changed in such a short period of time. I remember learning how layout used to be done by cutting and pasting—with actual scissors and glue. What?! During my process of researching for this book, I was browsing through an old textbook of mine and found a single paragraph dedicated to "the internet". Look how far we have come! Thankfully, we live in a very digital age that makes getting pen to paper to computer much easier!

Each designer's workflow and tools will differ. Here, I share with you what I use and how I use it. You can obviously pick and choose to create the perfect technological solution for your needs.

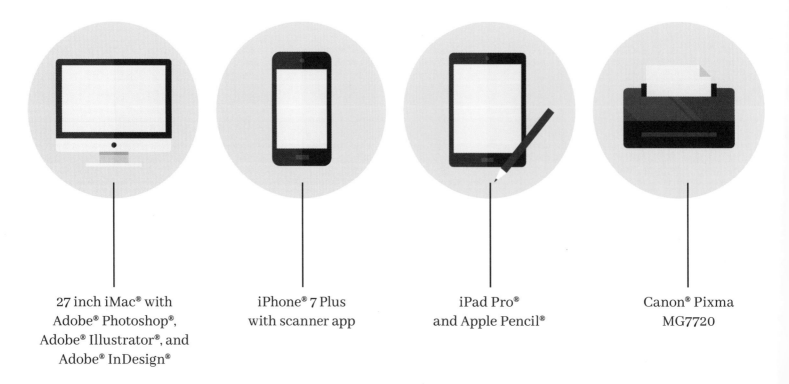

27 inch iMac® with
Adobe® Photoshop®,
Adobe® Illustrator®, and
Adobe® InDesign®

iPhone® 7 Plus
with scanner app

iPad Pro®
and Apple Pencil®

Canon® Pixma
MG7720

My 27-inch iMac has become a close friend. I have a creative mind, which is a nice way of saying that I am a bit messy. (I like to think of it as organized chaos.) Having such a large screen means I can easily navigate between different applications and windows. It also allows me to zoom in to see every aspect of my project. It's so important to see itty bitty details within your piece!

The 27-inch iMac, however, is not absolutely necessary, and will not be the magic key to your success. Find a computer solution that works for your needs, desires, and budget!

I use three applications on my iMac regularly: Adobe Photoshop, Adobe Illustrator, and Adobe InDesign. Each program is created for different uses and outputs. Let's break them down!

PHOTOSHOP	ILLUSTRATOR	INDESIGN
pixel based photo editing website design + layout	vector based illustrations logos + packaging	vector based page layout brochures + books

To create a final project, these programs work great separately or together! Adobe Photoshop is pixel-based and creates raster images. (Raster graphics are made of a ton of tiny pixels that create a single image.) Of course, Adobe Photoshop is best known for its photo editing capabilities. (And those capabilities are literally endless! Remember how I told you that technology has come a long way?) I use Adobe Photoshop for all of my photo editing, and also for web-based projects (blog graphics, website headers, slides, and product imagery, for example).

Website homepage slide was created with Adobe Photoshop in RGB color mode. The image is made up of a photograph overlaid with type and vector objects saved as a JPG or PNG.

Adobe Illustrator was my first love. I used to create everything in it. Then, I learned that each program is made for different uses. Imagine that! Adobe Illustrator was the first program I learned in school, and it was hard to kick the habit and resist the urge to create all my projects in it. Adobe® named their various programs to reflect what they are best for. Adobe Illustrator is (obviously!) known for its illustrations and vector art. Unlike raster graphics, vector graphics are made up of mathematical formulas that define curves, lines, and shapes. Don't worry: I can't even begin to understand that, either—but the takeaway is that vector graphics can be scaled without losing quality—perfect for lettering, fonts, and logos! I use this program to vectorize all my lettering and to create packaging and other graphics for my brand (like my logo, for example). While we're on the subject, let's look at a simple way to digitize your lettering!

1. Create your lettering piece.

2. Scan your lettering with a scanner, or use a scanner app (I use Scanner Pro®). If you are using an iPad, save your work as a PNG or JPG.

3. Share the file with your computer and open it in Adobe Illustrator.

4. Choose "live trace". There are several different options. Depending on the tools used, you will want to play around with each of the available options. Since my lettering usually features clean lines, I use the "sketched art" option.

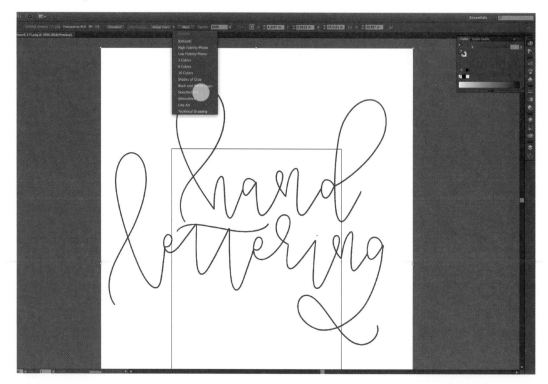

5. Now you will see your art outlined in blue. Click the "expand" button next to the live trace options, and the mathematical equations go to work and create the curves around your letters.

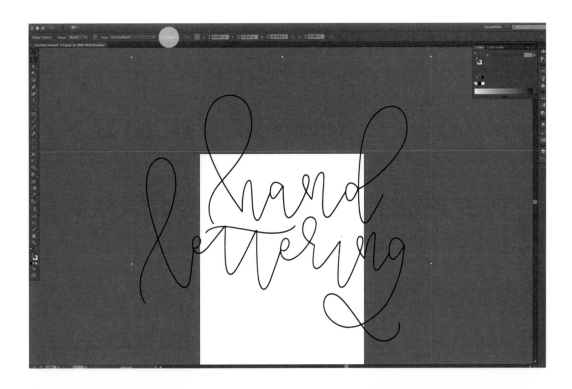

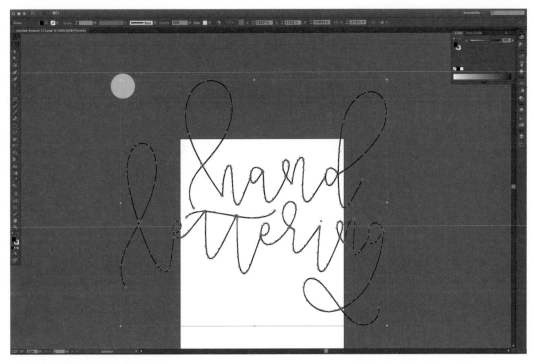

 6. If things aren't quite perfect, try a different live trace option, or clean up your strokes by manipulating the curve points with the direct select tool (the white arrow).

Pro Tip: The cleaner your letter is to begin with, the easier it will be to digitize. What do I mean by that? I encourage you to use quality tools that do not allow your ink to bleed. Also, try to keep your hand as steady as possible! However, depending on the final project, you might want to keep some of the messier lines or organic feeling of the lettering.

I started using Adobe InDesign when I worked for a company that formatted resumes. It was just one more learning curve! I don't use Adobe InDesign often (except for when I am writing books—like this one!). Adobe InDesign is ideal for page layout and for creating any sort of print collateral. It's similar to Adobe Illustrator in that it is vector-based. The output is for print, and most things are created in the CMYK color space. Adobe InDesign has some pretty intense paragraph and character styling functions, if you're into that sort of thing!

 Don't compare your beginning to someone else's middle.

—Jon Acuff

 The iPhone 7 is another key tool that I use in my design work—although I don't use it quite as often as I used to! When transferring doodles or other lettering to a digital format, I often use a scanner app on my phone (as I mentioned previously, I like Scanner Pro, but there are many others).

I also use my iPhone for my business photography, from quick product photos to a styled Instagram flat-lay. The camera just keeps getting better and better. (I'm sure that by the time this book comes out there will be another cooler, slimmer, better iPhone.)

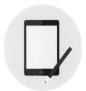 Since it was first introduced, I knew the iPad Pro would be a huge game changer for my business. I was lucky enough to grab one that year, along with the Apple Pencil. They were unlike anything I had ever used before. There are plenty of tablets that use pens or styluses, but I could never quite get them to work for me! The iPad Pro takes a bit of time to get used to, but it's seamless once you get the hang of it.

The possibilities with the iPad Pro + Apple Pencil are endless. The cool thing about the Apple Pencil for letterers is that it mimics the pressures that we use to create heavy and light strokes. Crazy, right? I use my Apple Pencil for most of my lettering designs. When I have an idea of exactly what I am going for, I grab the iPad Pro! There are a lot of great apps for illustrating and lettering. Adobe has a few iPad Pro design apps; the one I find best for lettering is Adobe® Illustrator® Draw. It works fairly seamlessly with Adobe Illustrator CC. You can create everything as a vector, and send it to Illustrator on your computer.

My favorite app for lettering and illustrating is Procreate®. I use this all the time! There are so many ways to use Procreate, and this is exactly why it is so widely used. Procreate is similar to Adobe Photoshop in that it uses layers and pixels. The designs created in Procreate can even be exported as an Adobe Photoshop file and transferred to your computer with the same layers you created on the iPad. (There are several other options to export in the Procreate app, including Pro, PSD, PDF, JPG, and PNG.) Most of these file extensions likely sound familiar to you. When transferring doodles or other lettering to a digital format, I often use a scanner app on my phone. (As I mentioned previously, I like Scanner Pro, but there are many others.)

A LOOK AT PROCREATE

Procreate can be an intimidating app. When I first started using it, I was like, "What the heck is happening? What do all of these things do? Why do I need them?" Truth is, you don't need to know it all. You can start with the basics and still get great-looking lettered pieces!

When you open up the Procreate app, you will see a blank black screen and a "+" sign at the top right. Click that once, and you will see "Create". For a blank canvas, I usually choose the "Screen Size" option. This automatically creates a canvas that is the resolution of your iPad. You will also see options for other basic sizes, as well as the ability to import a canvas. If you know the final size of your project, you can create a new canvas to those specific dimensions. This is super helpful when you want the lettering to fit a certain way.

Procreate comes with some great basic brushes, but you also have the ability to add any custom brushes that you'd like. As you see here, I have a list of imported brushes. These are my ten go-to brushes for iPad lettering. I have gotten three of these for free at iPad Lettering; if you search you can find a number of free custom brushes.

The different brush styles are what makes iPad lettering so fun! You can recreate things like chalk art, brush lettering, and even get an ink bleed all on the same device with just one pen + no mess. Praise!

When purchasing different brushes for Procreate, each maker will usually include detailed instructions on how to import them into the Procreate app.

brushes eraser color

Gallery

Ink Bleed

layers

takes you back
to your gallery

streamlines
your letters.
(you'll understand
better when you use it.)

controls the
size of your
brush

controls the
opacity of your
brush

redo + undo
(lifesavers)

To the left, you'll see the basics of what you need to know for lettering. Here, I am inside my brush settings. I got here by clicking my brush icon, and then selecting my brush.

Procreate has a "streamline" function that automatically cleans up your letter curves. If you are looking for more natural movements, keep this anywhere from 0-50. I usually keep this feature turned all the way up to 100. When you download specific brushes, they have already been fine-tuned by the maker, so no need to mess with the settings unless you are creating a new brush from scratch!

Just like any new skill, lettering on the iPad does take some getting used to. The way the Apple Pencil glides against the glass of the iPad can be pretty hard to control and is very different than writing with a pencil on paper. Just like when you are learning to letter with traditional tools, take it slow and practice a lot!

When everything is designed, it is time to print and proof! We have discussed the various color spaces in which different projects are produced. When creating a design for print, it is imperative to use a well-calibrated printer. After all, the way we see things on our screen is very different from how they appear in print, right? It's always good to share this with your clients, too, because proofing something over a computer is very different from proofing something in print! I use the affordable Canon Pixma MG 7720, and so far, it is my favorite printer. If you are having something professionally printed, you can always ask the printer to send you physical proofs to approve.

PART THREE

PROJECT 1: ENVELOPES

 Let's make some snail mail extra pretty!

SUPPLIES

- ✖ Envelopes
- ✖ Pencil
- ✖ Fine point pen (I use a Micron 05 & 08)
- ✖ Brush pen (I use Tombow Fudenosuke Brush Pen)
- ✖ Ruler
- ✖ Practice paper

HOW TO

1. Grab some of your favorite stationery! Don't have any? I snagged all of the pretties you see on page 119 at my local craft store.

2. Review the alphabets in this book and decide which you want to use for your envelopes. I used a mix of Hillary, Sarah, Meg, and Emma.

3. Grab your tools! (You know I will choose a pencil and a Micron pen for mine!) Not very good at writing in a straight line? Grab a ruler, too!

4. Use your pencil to lightly draw guidelines across your envelopes. This gives you an idea of where your baselines will be, so you will be able to make your letters dance or keep them as straight as you'd like! There are no rules!

5. You have the option to do your entire design in pencil first (this might save you an envelope or two). I actually cut out pieces of paper similar in size to my envelopes and practiced a few designs until I felt confident enough to grab my pen.

6. When you're ready, put your pen to the envelope! If you feel daring, add a few doodles and banners to your envelopes. You can see a few of my designs on the following pages.

Match each of these descriptions to their corresponding image on the next page:

1. For this envelope, I used a Micron pen. This felt pretty and formal to me—but not too formal. I used the Emma Alphabet sans down strokes, and I really focused on staying on the same baseline and extending my tails out.

2. This envelope was a bit more fun! I mixed a few alphabets together. I worked with the Kate Alphabet for the "Mr. and Mrs." and I added a little ribbon to the "and". I used a tall and skinny sans serif with generous letter spacing for the name, and finished it off with the address in the Emma Alphabet minus the down strokes. I used a Micron pen for this envelope, too—either the 05 or the 08 works well here.

3. This envelope features the Hillary Alphabet and the Alli Alphabet (for the capital letters). I used a Tombow brush pen. This is a bit more traditional and formal! I focused on fast and fluid letter forms.

4. In this design, I added a banner that moved with the curves of the "T" cross stroke. I used the Sarah Alphabet, and did not fill in my down strokes. I finished it off with a skinny and spaced-out sans serif.

TUTORIAL: BANNER

1. Begin with the main banner shape.
(It doesn't have to be curved!)

2. Draw the two ends of the banner just behind
the initial shape.

3. Finish the banner with strokes that connect
the ends to the main shape.

In this image, you can see the
individual strokes.

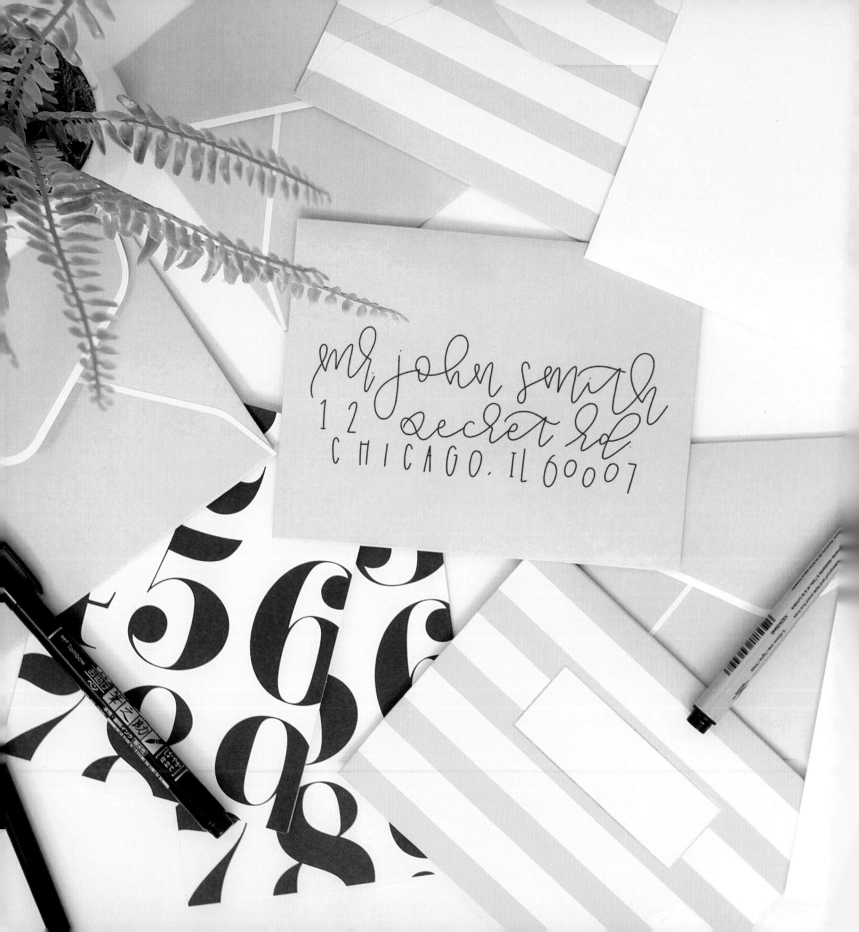

mr. john smith
1 2 secret rd.
CHICAGO, IL 60007

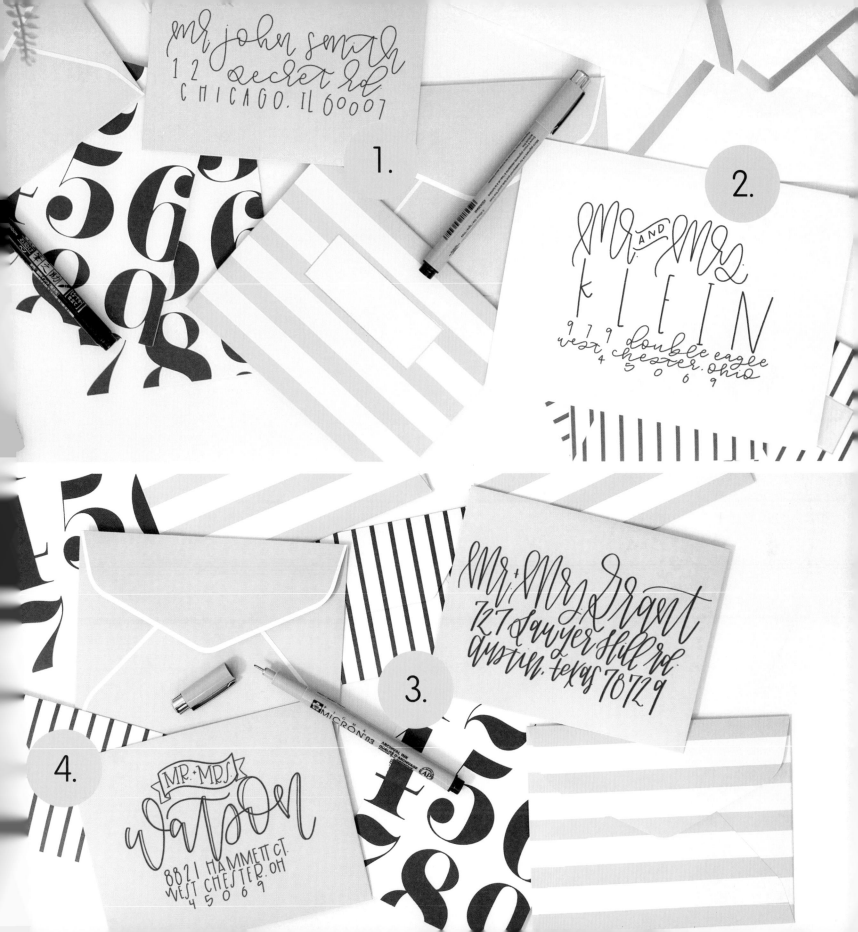

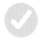 Use this page to practice the project!

 Let's make some cards to put inside your cute envelopes!

SUPPLIES

✖ Blank cards
✖ Variety of stickers
✖ Confetti (optional)
✖ Markers (I used Brea Reese® dual-tip water based markers)
✖ Brush pens (I used Brea Reese metallic brush pens)
✖ Ruler
✖ Pencil

HOW TO

1. Gather your blank cards and all of the fun stickers and accessories that you have to play with.

2. Review the alphabet sets in this book and decide which ones you want to work with. I chose a mix of Sarah, Meg, and Emma, but be creative and try a few different combinations to see what you like.

3. Grab your pencil and ruler and start designing! Lightly draw some designs across your cards to get an idea of spacing and to make sure that your design ends up where you want it. There are no rules here, so have some fun! Use your stickers as inspiration for your own saying, or use the designs on the following pages to get started!

4. Finally, put your pens and markers to your cards! If you feel daring, add a few doodles and banners to spice things up!

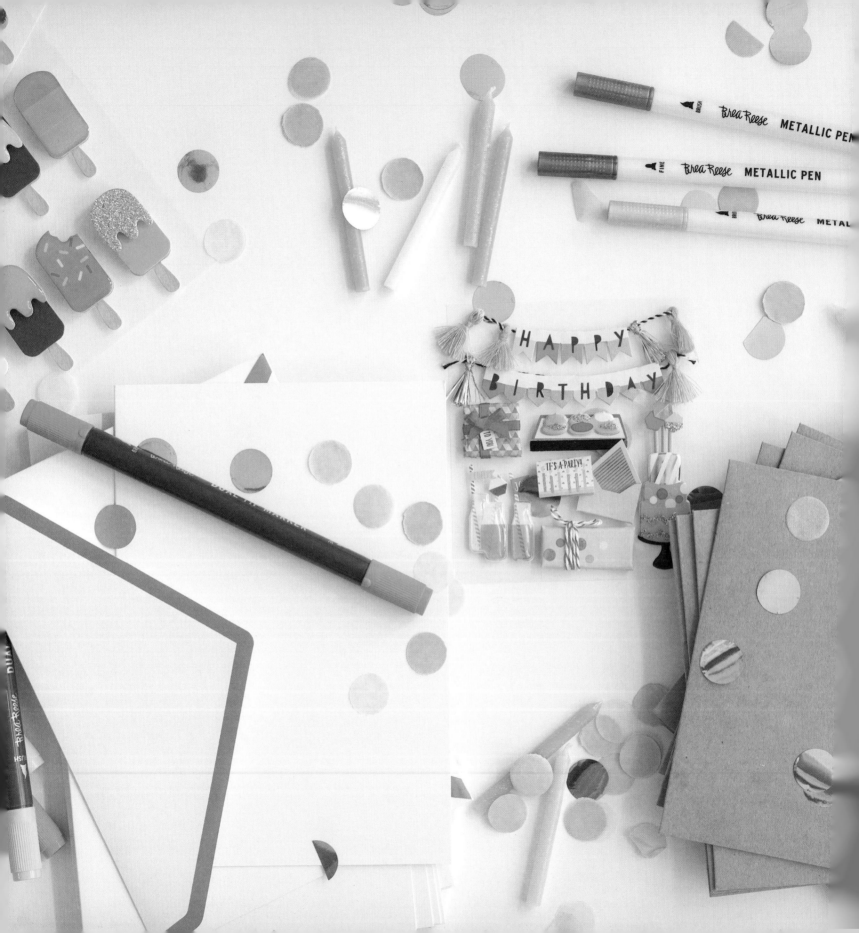

2. THANK you

3. cake ENOUGH SAID.

1. HAPPY birthday laura

BIRTHDAY

4. cheers TO YOU!

 Trace + practice before starting your project!

1.

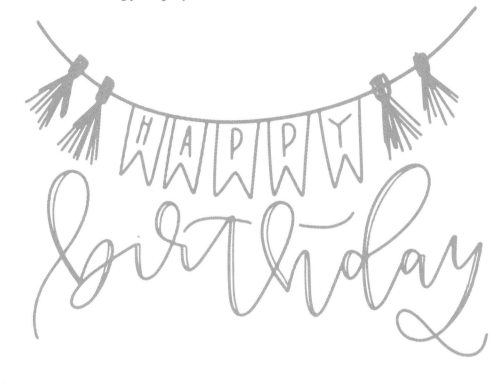

2.

 Trace + practice before starting your project!

3.

cake
ENOUGH SAID.

4.

cheers
TO YOU

 Use this page to practice the project!

PROJECT 3: ALTERNATIVE PLACE CARDS

 Place cards are a great way to personalize + add something unique to your next dinner party!

SUPPLIES

✗ Alternative place card (I used lemons and tiny succulents, but it could be anything!)

✗ Sharpie Paint Pen (Water or oil-based pens are best.)

HOW TO

1. For this lettering project, I tried to think of a few different ways we could display someone's name at a summer dinner party! I am having a bit of a lemon moment and thought they would add a fun pop of color, and when I came across these adorable tiny succulents, I couldn't resist, so I decided to give them both a try. The truth is, you can use anything you want as your place card!

2. I recommend that you choose an alphabet you are comfortable with, as writing on difficult surfaces can be challenging.

3. Grab your tools! I chose some water-based Sharpie Paint Pens. They worked great on both the lemons and the cactus pots. You can also use oil-based pens.

4. Plan out each name on each different surface. Save the bigger lemons for longer names!

5. Put your pens and markers to your surfaces. It is always a good idea to grab a few extra of each place card in case you mess up. Don't worry—it happens to all of us. I like to hold each object in my hand when writing, and to go very slow! Let it dry completely before you do your downstrokes.

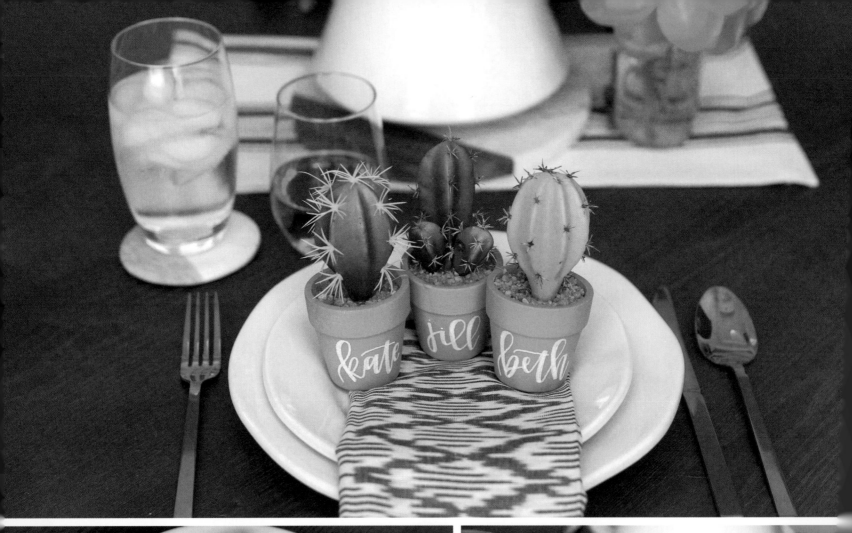

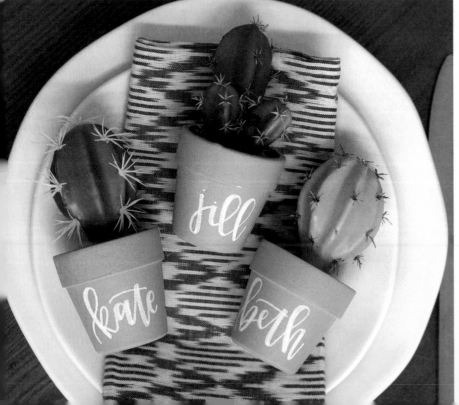

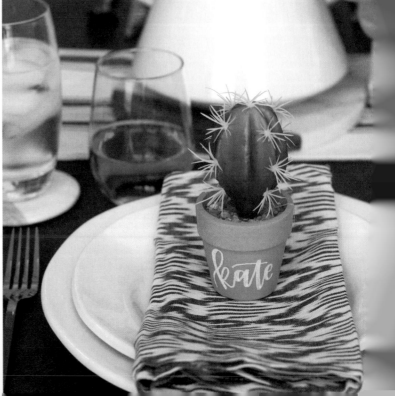

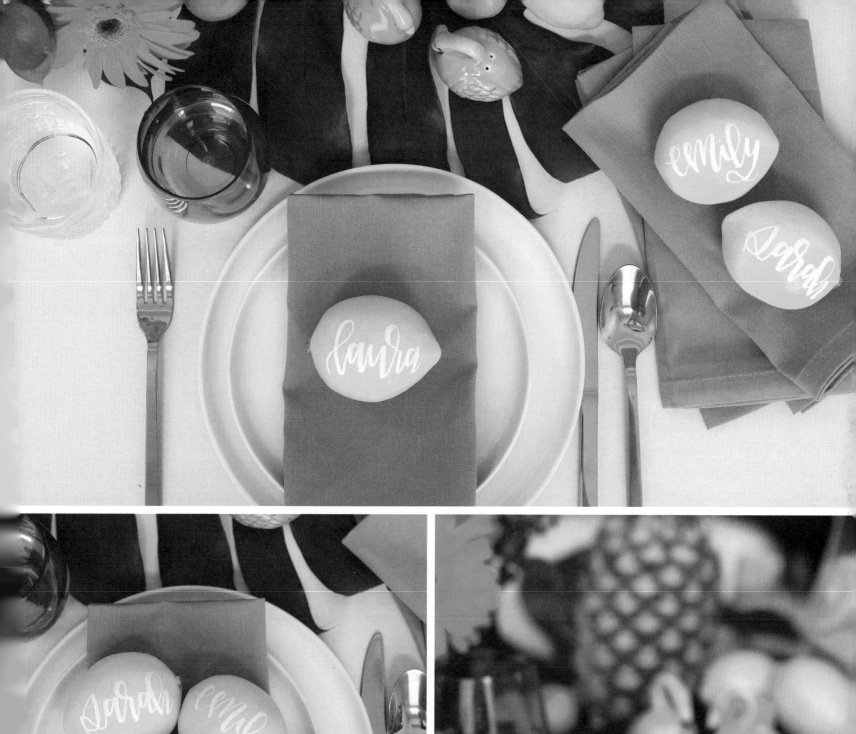
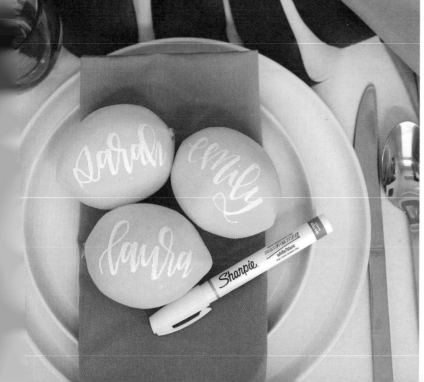
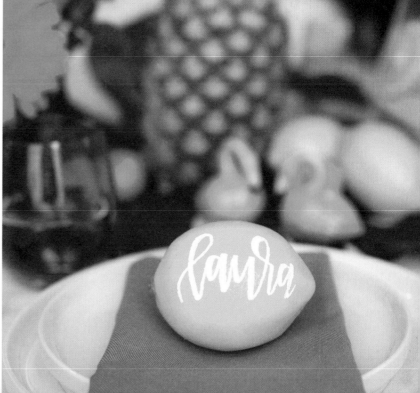

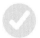 Use this page to practice the project!

PROJECT 4: FALL KITCHEN SIGN

 Add some fall flavor to your kitchen with this cute cutting board sign!

SUPPLIES

✗ Cutting board

✗ Marker (I used a large black marker by Sakura®)

HOW TO

1. This one is easy-peasy, and requires two tools you can pick up from your craft store! This cutting board was only a few dollars.

2. Go back through the alphabets and decide which ones you want to work with for your fall sign. I chose to use the Sarah style again. Imagine that!

3. Use a pencil to sketch out your design on the cutting board to get your placement where you want it.

4. Go over your design with your final tool. Since I wanted this to make an eye-popping statement, I used a dark contrast color. A metallic gold would also be really pretty. If you wanted to step up your craft game, try painting the cutting board your favorite color, and then lettering over the paint. Remember, this is just for looks! Using marker or paint means that this cutting board won't be food-safe. However, it will look lovely hung on a kitchen wall or propped on the countertop with some cookbooks.

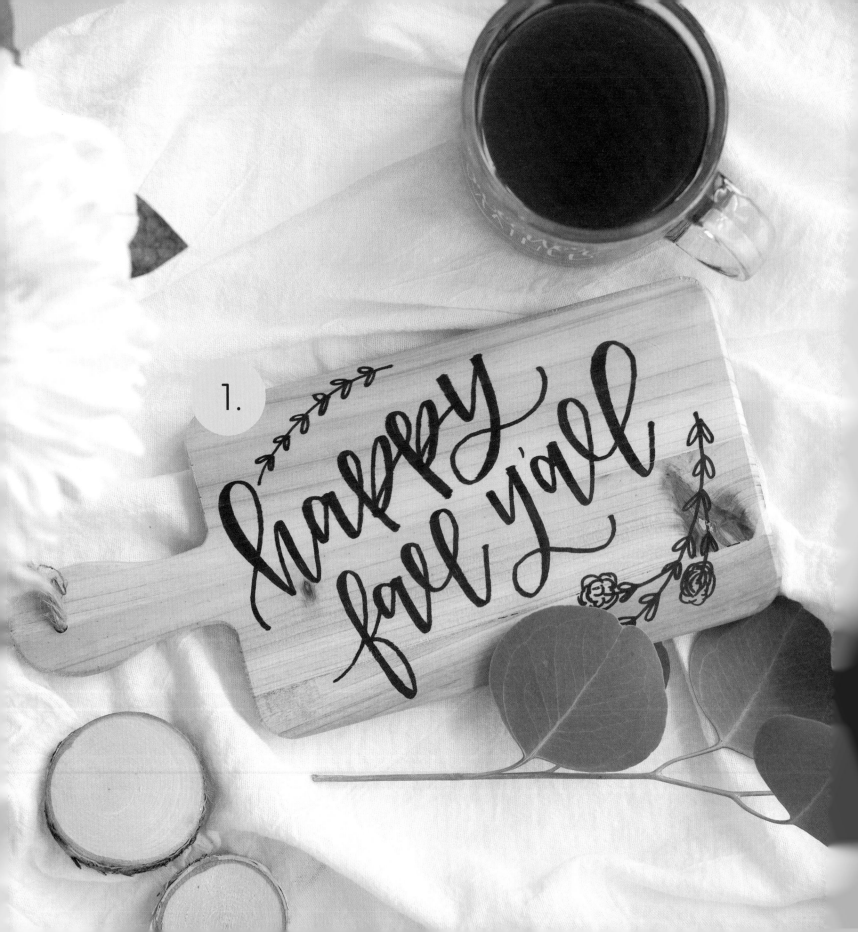

 Trace + practice before starting your project!

1.

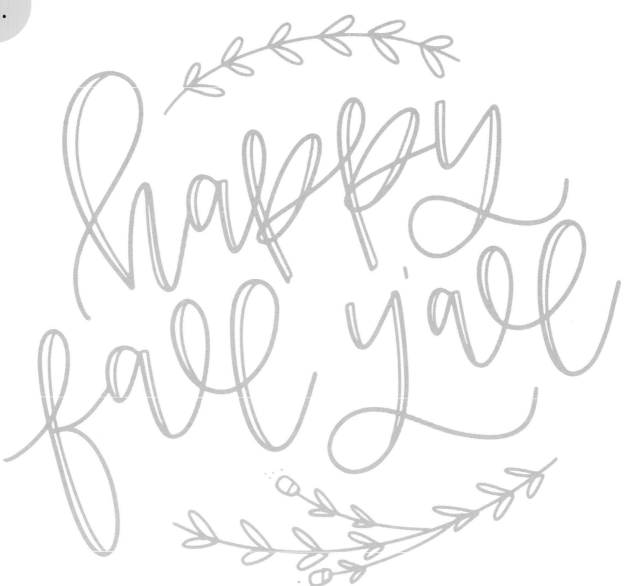

 Use this page to practice the project!

 Use this page to practice the project!

PROJECT 5: CHRISTMAS WRAPPING

 No need to buy expensive wrapping paper when you can make your own pretty paper for less!

SUPPLIES

✘ Kraft boxes or kraft wrapping paper

✘ Colored markers (I used Koi Coloring Brush Markers & Sharpie Paint Pens)

✘ Holiday stickers

HOW TO

1. I got such a great response when I shared my decorated Christmas packages last year that I knew I had to share this craft with you. This is a super easy way to personalize your packages on a budget, and it is sure to get you the title of "best wrapping" at your annual holiday award ceremony.

2. Go back through the alphabets and decide which ones you want to use. I chose Emma and Sarah, and used a brush pen for a different look.

3. I suggest having some fun! Try mixing it up and add some doodles or banners for a little something extra.

4. It's time to put pen to wrapping paper! First, decide whether you want to trace out everything, or if you want to free-hand it! Be creative. I always like to go a little over-the-top around the holidays, so pile it on!

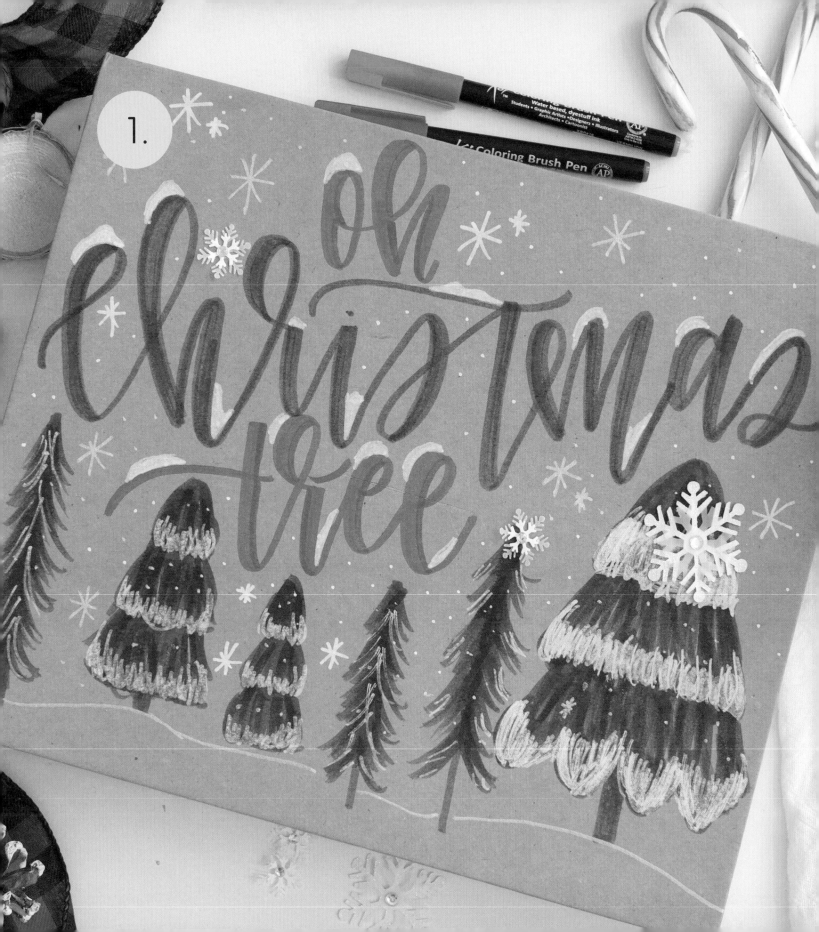

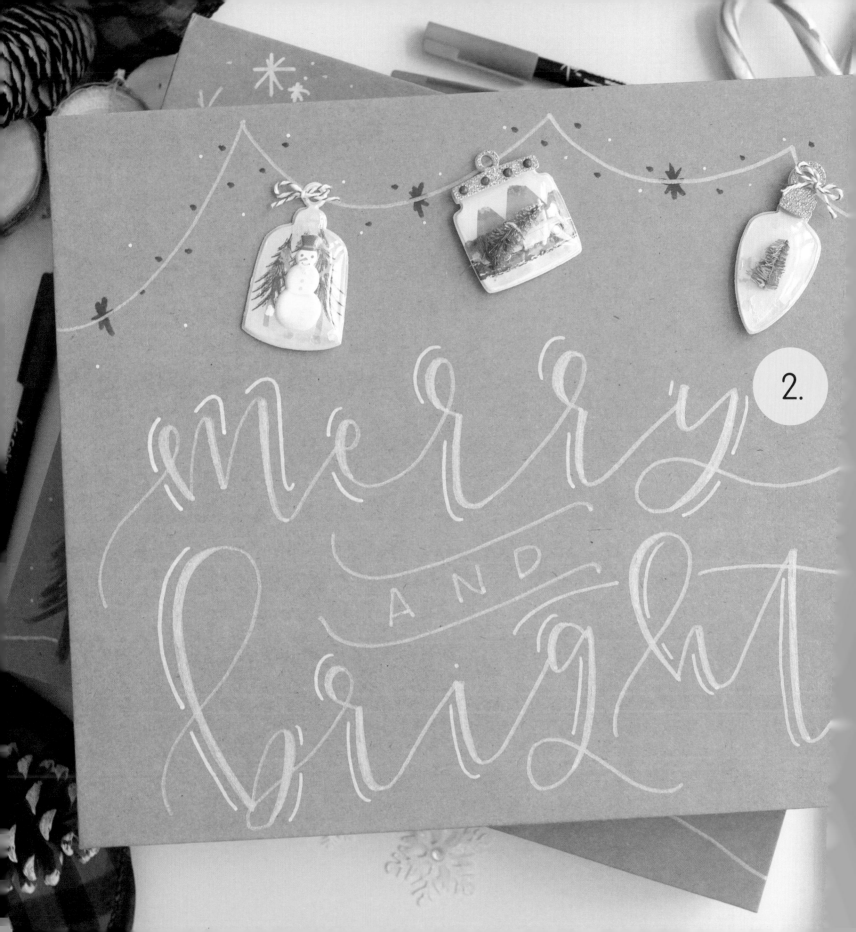

merry *and* bright

2.

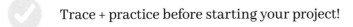 Trace + practice before starting your project!

1.

oh christmas tree

2.

merry AND bright

3.

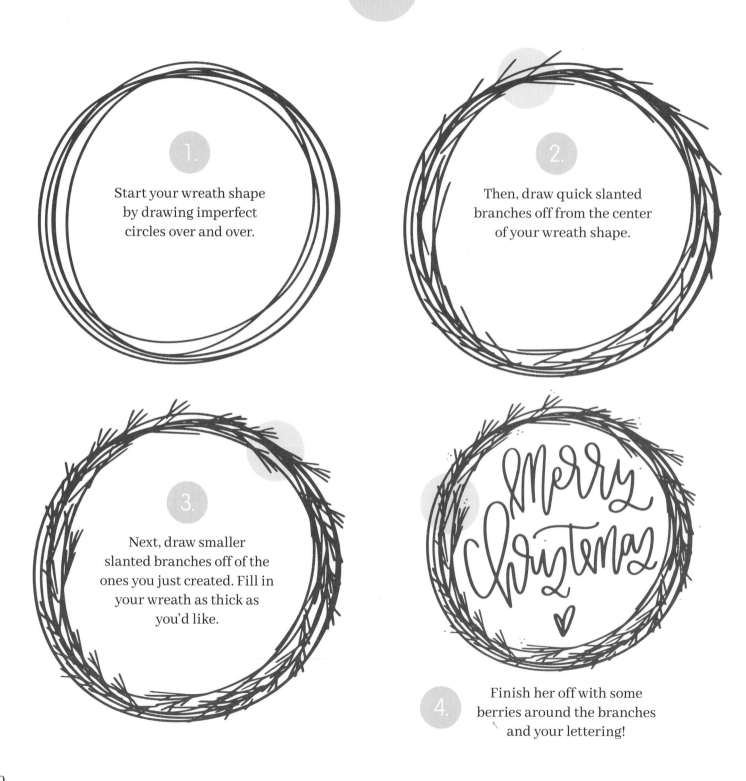

1.
Start your wreath shape by drawing imperfect circles over and over.

2.
Then, draw quick slanted branches off from the center of your wreath shape.

3.
Next, draw smaller slanted branches off of the ones you just created. Fill in your wreath as thick as you'd like.

Merry Christmas

4.
Finish her off with some berries around the branches and your lettering!

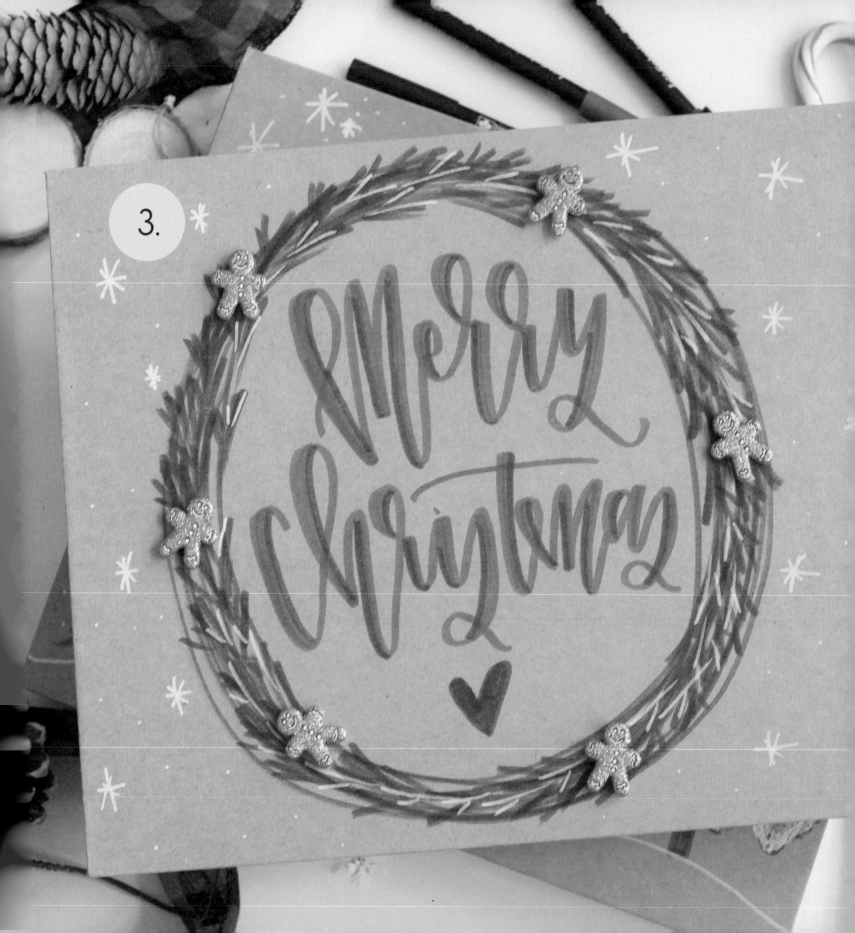

 Use this page to practice the project!

Woo! You made it to the end. Do you feel inspired? Encouraged? Ready to take on the world? I hope so—at least the lettering world! I am so glad you decided to join me again for *Hand Lettering 201*. I cannot wait to see what y'all create with your newfound skills! I cannot thank you enough for supporting me on this journey and I truly hope you learned so much!

Make sure to tag me in all of your book + project posts on Instagram! Use #handlettering201 and @chalkfulloflove

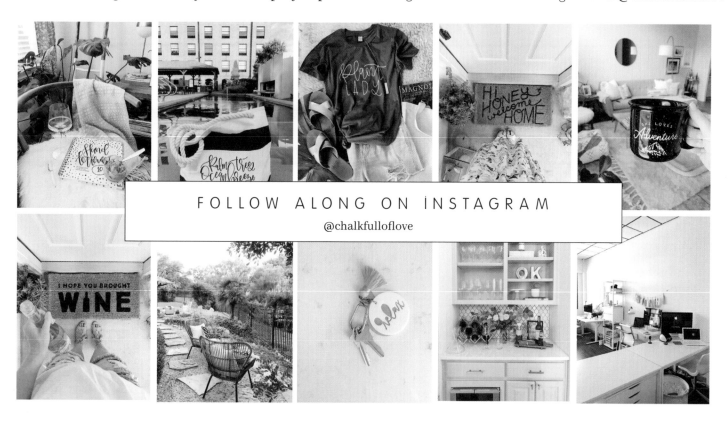

FOLLOW ALONG ON INSTAGRAM

@chalkfulloflove

paige tate
& CO.

Copyright © 2017 Blue Star Press
Paige Tate & Co. is an imprint of Blue Star Press
PO Box 5622
Bend, OR 97708
www.paigetate.com

For details or order information, contact the publisher at email
contact@paigetate.com.

Written and illustrated by Chalkfulloflove

Adobe®, Adobe® Color, Adobe® InDesign®, Adobe® Illustrator®,
Adobe® Illustrator® Draw and Adobe® Photoshop® are registered trademarks
of Adobe Systems Incorporated in the United States and/or other countries.

Adobe product screenshot(s) reprinted with permission from
Adobe Systems Incorporated.

Apple Pencil®, iPhone®, iMac®, and iPad Pro® are trademarks of Apple Inc.,
registered in the U.S. and other countries.

ISBN: 9781944515546

Printed in China

10 9 8 7 6 5 4 3 2 1